graffiti PARIS

graffiti PARIS

Photographs by Fabienne Grévy

Abrams, New York

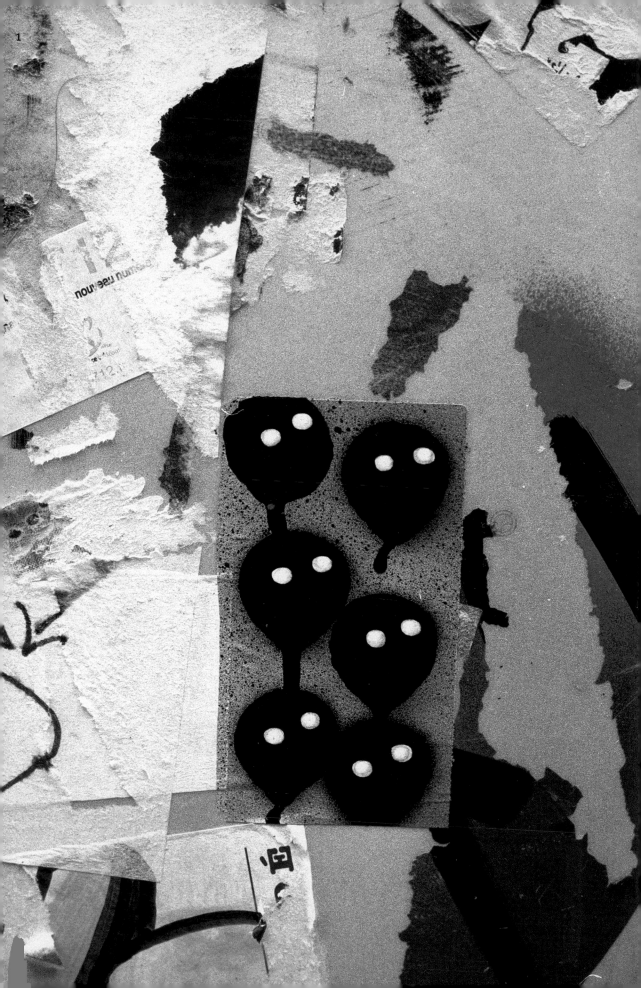

Paris wanderer,

Look around and take notice of the traces left by street artists on the city's walls and pavement. Rethink the city, rediscover its surfaces, and map out walks that may lead you to new graphic horizons. Cross the street if you must, step a little closer, and spot everything in the City of Lights that has been painted or pasted just for you. Keep your eyes open and keep walking—maybe there will be something else to see way down at the other end of the street. Find something in the least imaginable places, choose what to look at—beauty is where you discover it—and interpret the artistic messages that are being communicated to you.

This is an adventure that takes place in the street. Like many other areas of urban culture, for example street fashion, street art has its own visual codes. The word "graffiti" refers to inscriptions and drawings made on walls, which also encompasses those controversial spray-painted tags—authentic claims to a graffiti writer's identity—that began to proliferate throughout Paris beginning in the mid-1980s. These signatures were inspired by the lettering styles developed by early American graffiti writers, the pioneers of the modern graffiti movement in the 1970s. This aspect of graffiti has had a bad reputation, for it is the writer's goal to place his or her signature in as many places as possible, often in blatant disregard of property. This is also the form of graffiti writing most visible and, to the critic, the least attractive. Yet over the past twenty years, artists have evolved the graffiti genre by creating new signs, pictures, and logos to distinguish themselves from previous generations, and to rise out of the current crowd. These new forms of pictorial writing have resulted in what one may view as a "post-graffiti" movement, which is revolutionizing urban inscriptions with new graphic elements and also transforming calligraphies and signatures into recognizable urban culture icons.

For more than fifteen years, my father and I went to the places where we knew we'd find these inscriptions and we photographed them. We wandered through the city enjoying the hunt. Over the years, we've put together our

private collection. In assembling it for this volume, we conceived of the collection as an imaginary museum, an unlikely retrospective. Though our "museum" is far from exhaustive, the goal is to provide a sampler of all the styles found in Paris and to draw parallels between their various meanings and forms.

As the journey begins, one will discover a network of signs, some of which are unexpected, humorous, provocative, or sometimes naive, yet never insignificant, always poetic and decorative. These flashes of genius include an army of silk-screened monsters, a yellow cat with a wild grin, compasses to avoid getting lost, animals levitating, naked men chastely hiding themselves from view, glassy-eyed pigeons, satirical electoral posters, pieces of excrement rising to power, piles of pooh, strange-colored cows. These heterogeneous images coexist, creating a fabulous open-air museum with constantly evolving displays.

Symbols and logos are mixed in with figurative images, creating a visual dialogue between street artists and the passersby who decipher them. There is beauty in the air, a lightness induced by these hypnotic symbols. Some can be read from afar, some are easily identifiable, some are large and some are small, and many are constantly repeated to elicit instant recognition. Whether it is a 13 x 10 panel or the tiniest sticker, everything takes on a new dimension when its museum space is the city. And once the passersby take hold of it, they contribute their own interpretations.

Techniques and media vary widely, providing a vast range of results: painting, stenciling, mosaics, collages, diverted posters, photocopies, and silk screens all testify to this diversity. Pasting a piece of art in the street, making a stencil, or installing a small mosaic may not take long and can be repeated over and over. The repetition of all these signs made in a kind of creative euphoria bears witness to the vitality and dynamism of the artists responsible. You have to repeat yourself to resist, resist to exist and leave a trace of your passage.

These are the works of individuals, trajectories crossing paths in the city and leaving aesthetic traces with sometimes radically different agendas. Just imagine all these activists working in the street, experimenting with the city's public surfaces. Some call themselves artists, others do not. Some advocate "post-graffiti" art, others believe street art is not a legitimate form of graffiti writing. And though some may always work alone while others may collaborate with a graffiti or street art "crew," each person is sharing a story or an experience that is clearly unique and has pushed its expression somewhere other than in a studio or a gallery. These artists are superstars of the city who have chosen to conquer the urban grid. They are on the offensive, ready to invade the city. Along with Amsterdam, Barcelona, Berlin, London,

Los Angeles, Mexico City, New York, São Paulo, and Tokyo, Paris is one of the major capitals in the world where these artists come to make their marks.

Though there is an innate desire to be recognized, most of these artists choose to remain faceless. This is also a world for the initiated, a city and sidewalk culture that demands to be explored. The element of mystery and the forbidden—as this is an illegal art—provides its creators with a particular aura. It is as if there was something secret, a discreetly developed and strangely gratuitous action that left persistent traces in our collective unconscious the way subliminal images do.

Public surfaces are the blank pages in the book of urban art. As was once written in the street: "Only silent peoples have white walls." Everything here is in a dialogue, provoking discussion and reflection. Using walls and other public surfaces as a medium, as a kind of street paper, tears down the walls of the studio. The wall, an object of protection, property, and isolation, becomes the vector of a new form of expression. In fact, the wall can be truly beautiful and is carefully chosen as an integral part of the work. Whether cracked, brightly colored, uneven, or blistered, these precious surfaces are affectionately decorated with collages and stencils. The city becomes much more beautiful once decorated with motifs other than those of a hyper-mediated consumer society. Street art also combats indifference toward ill-defined, in-between places. Wastelands, blind alleys, and disaffected stores and homes are infra-worlds in which one can detect numerous objects of curiosity and wonder.

The street encourages encounters. Generations mix in the street and participate in this open-ended, collective, and free art seen by the greatest number of people. It is a new form of popular art, outside the frame and the picture rails, a gigantic game played inside Paris and people's memories. Is street art graffiti? Art or not art? In or out? Appropriated by commercials and designer brands, street art has become trendy. It is part of the zeitgeist. It has imposed its rhythms and colors like an avant-garde would. Urban activists have found their own way of writing a new page of contemporary art history in the city.

What remains? Memories. This collection of signs is irrevocably fated to destruction. It is progressively disappearing, dissolving with each spell of bad weather. The city's sanitation services are also inexorably erasing the traces of its presence. Only the camera can preserve this sort of artistic break-in that has yet to find a name in the books of art history.

F. G.

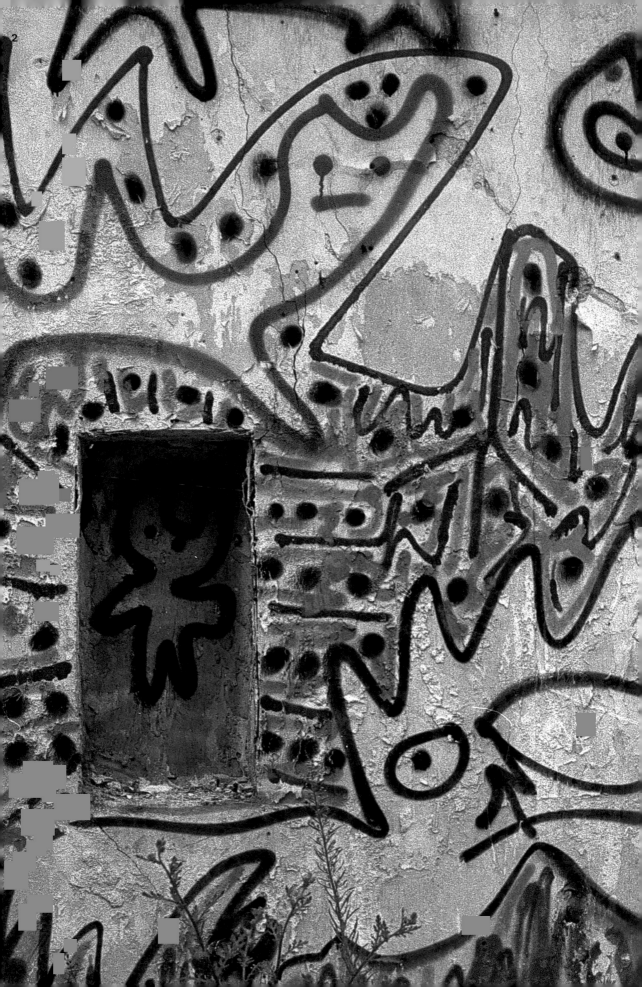

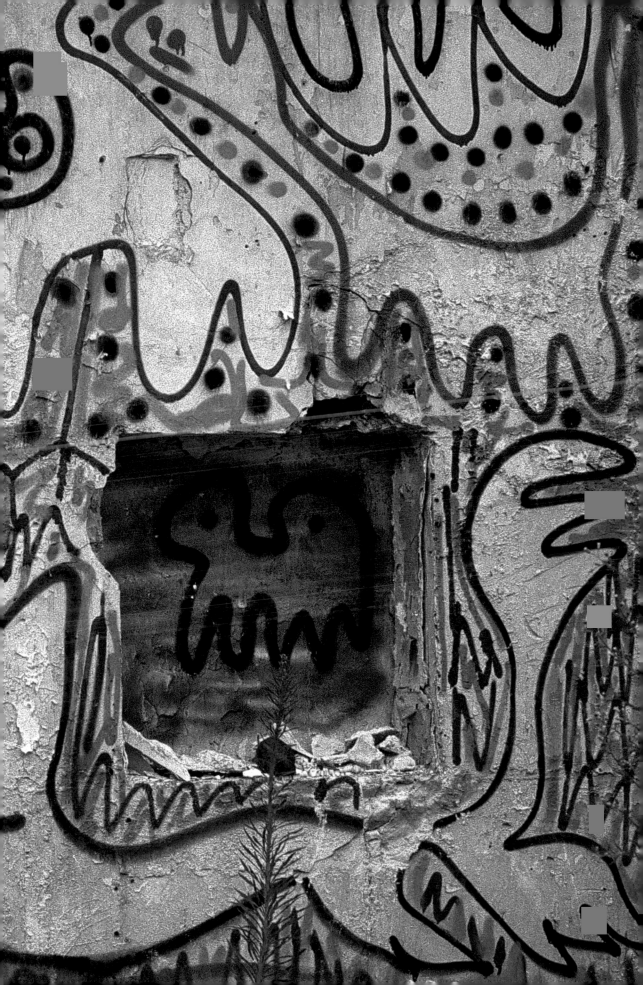

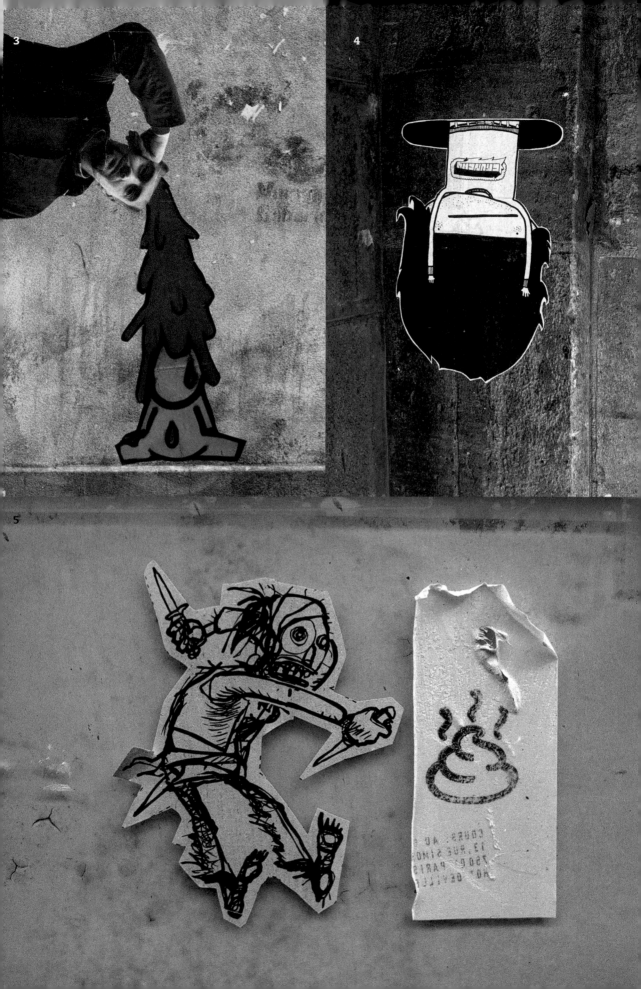

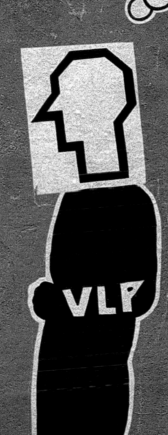

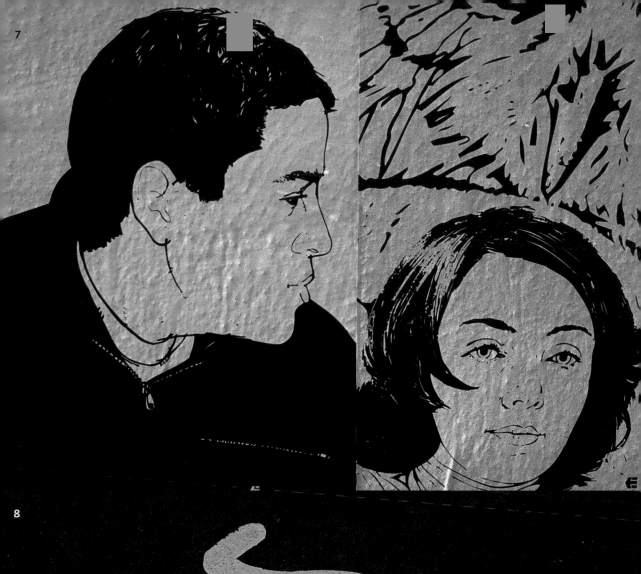

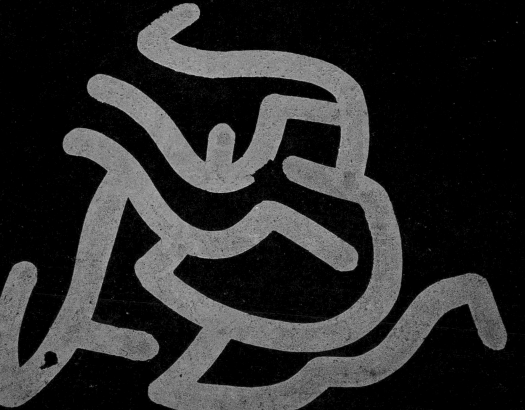

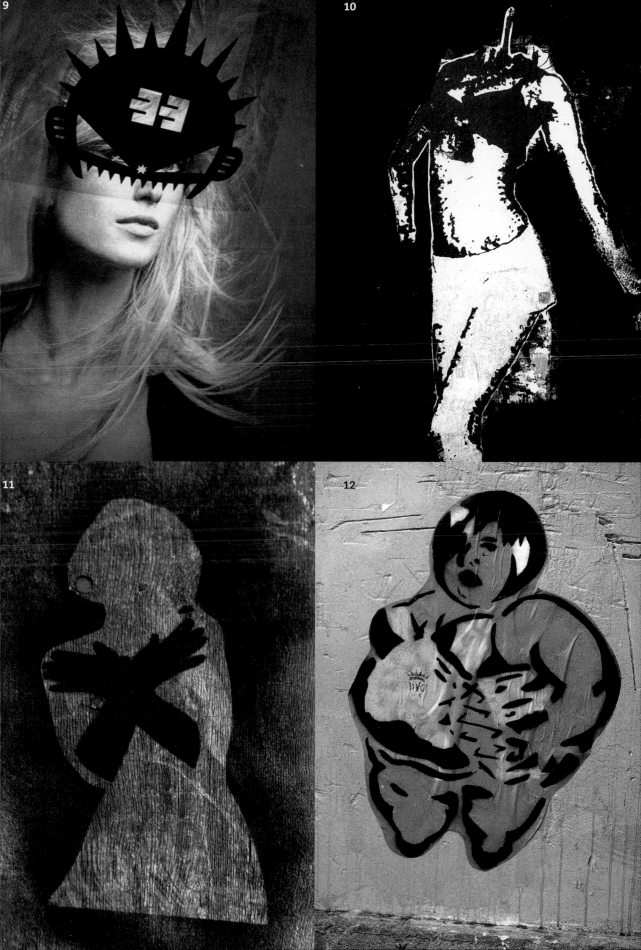

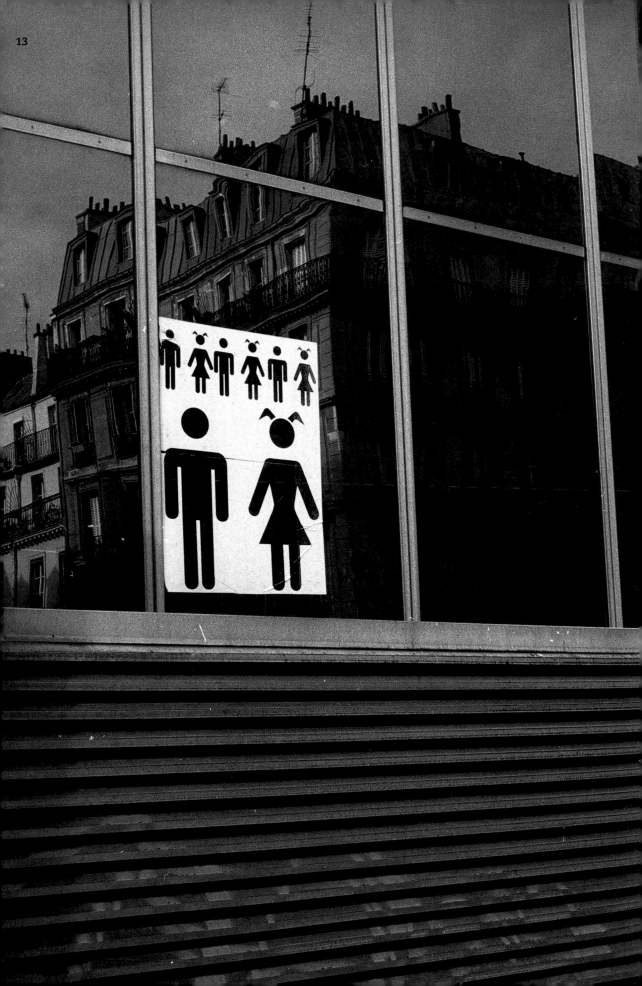

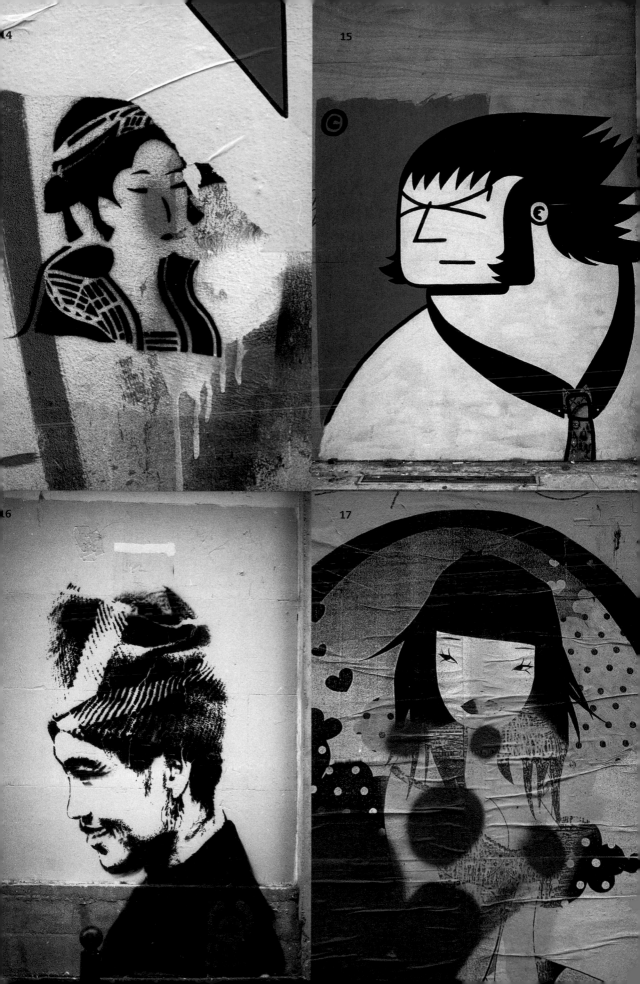

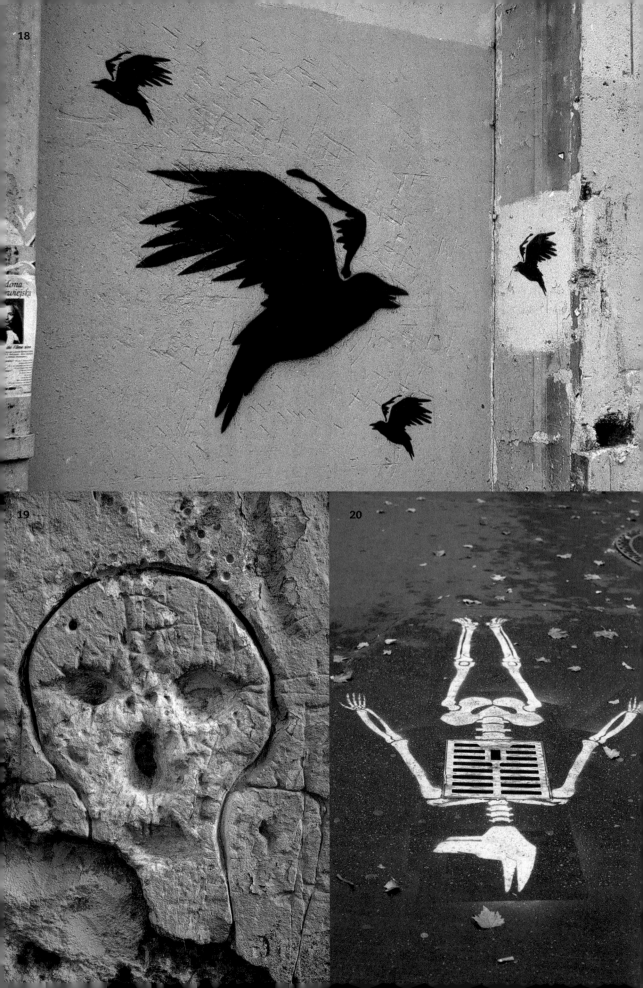

18

19

20

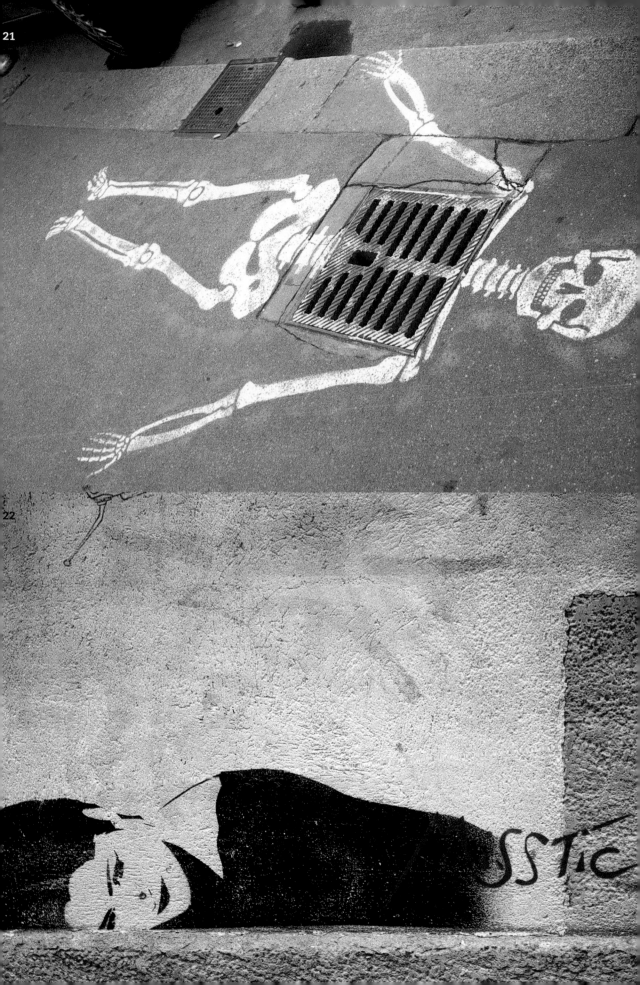

CHiEUR
De
LetTreS

Perdre sa Vie
A la gagner

UN SEUL
RÊVe !

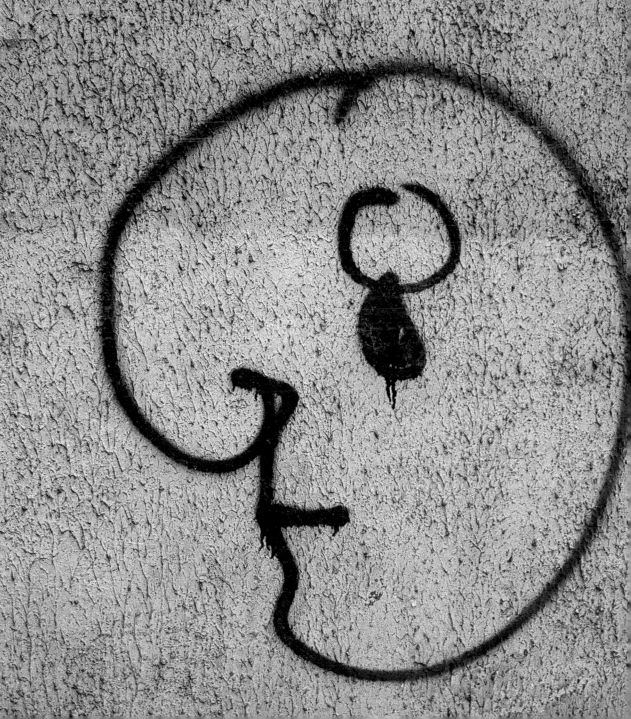

DÉFENSE d'AFFICHER

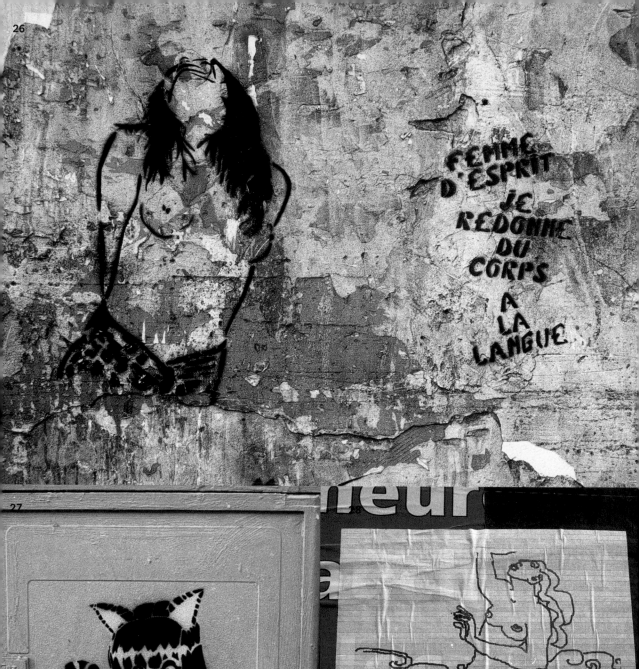

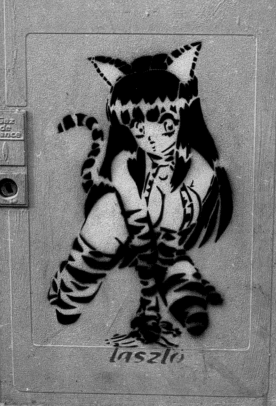

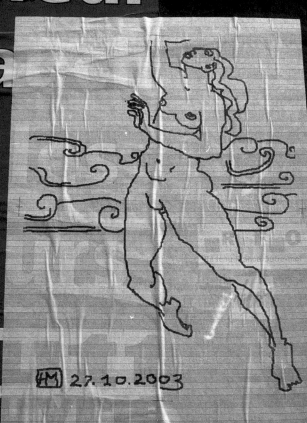

29

30

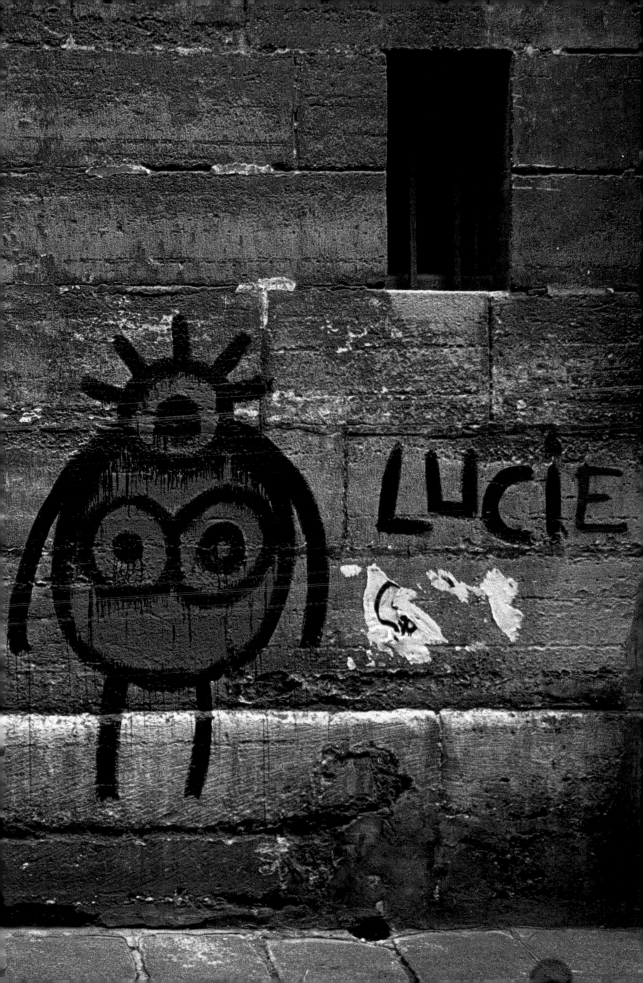

32

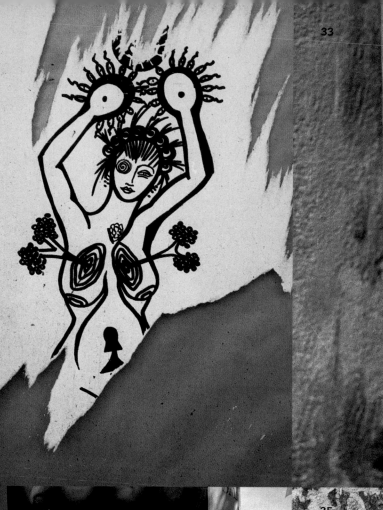

33

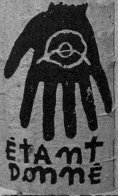

34

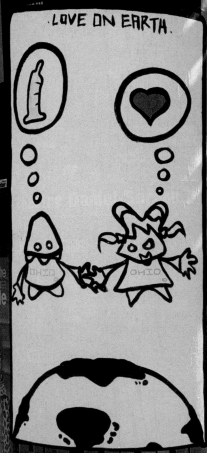

LOVE ON EARTH.

35

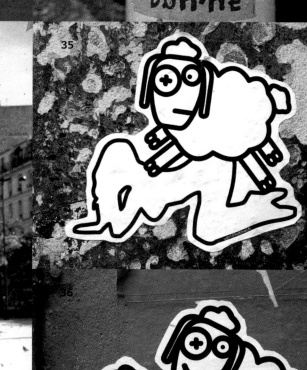

36

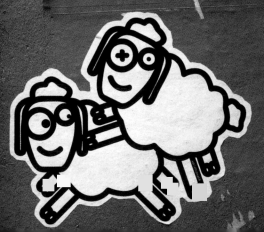

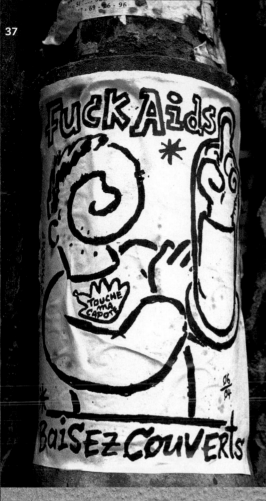

37

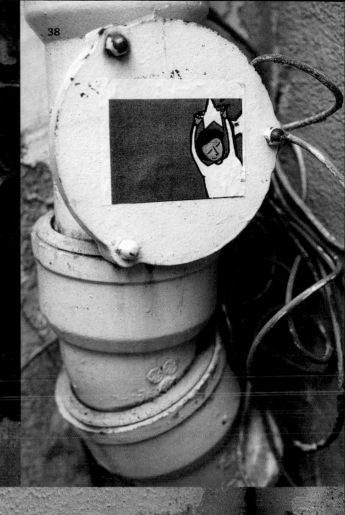

38

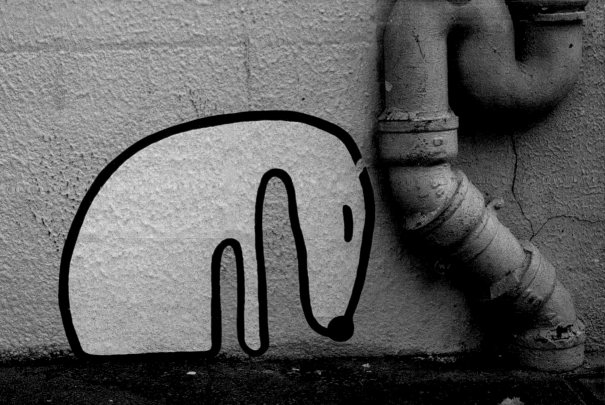

39

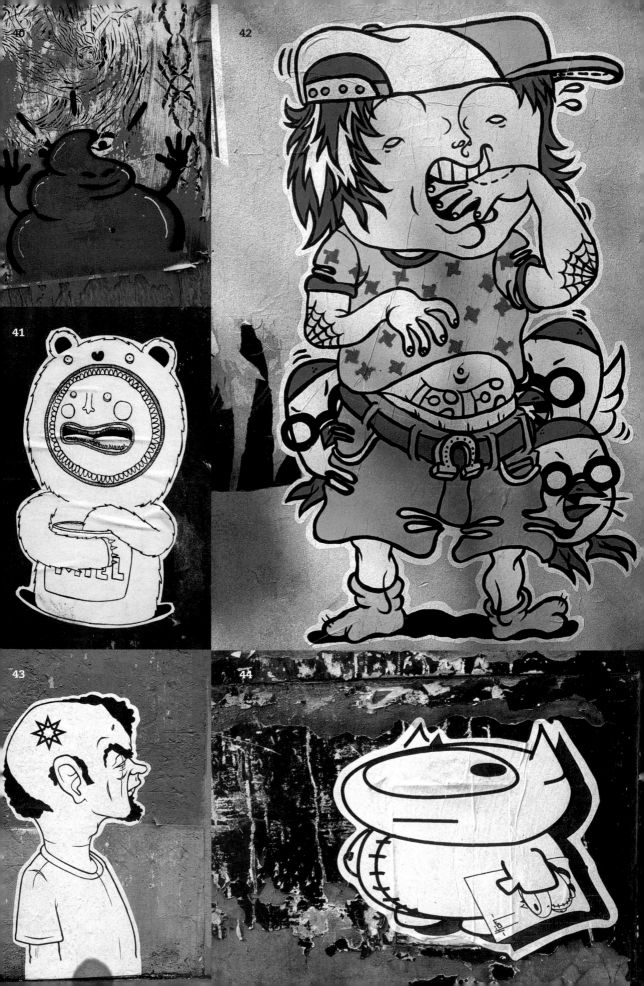

46

47

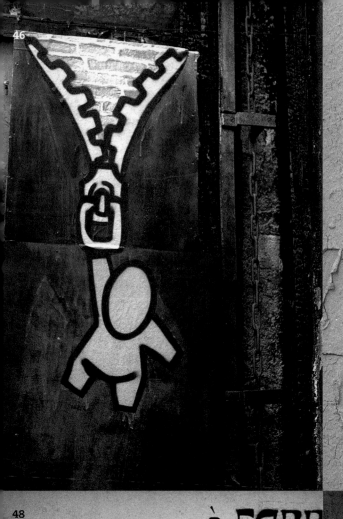

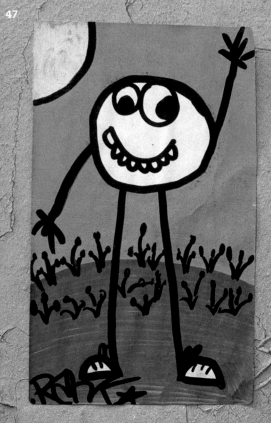

48

à FABR

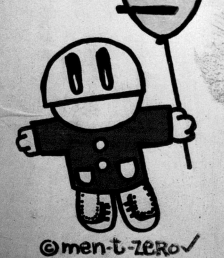

@men-t-zero✓

49

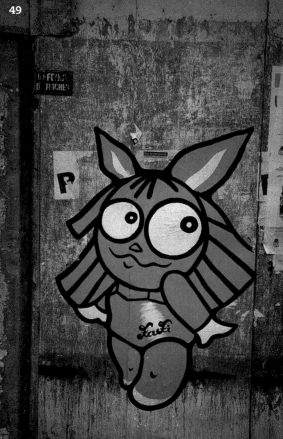

graffiti

Même si vous ne
le voyez pas d'un
bon œil
le paysage n'est
pas laid
c'est votre œil
qui
peut-être est mauvais.

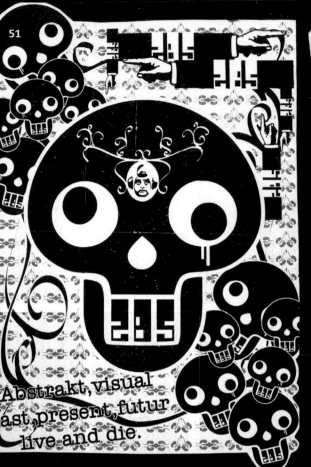

51

Abstrakt, visual
past, present, futur
live and die.

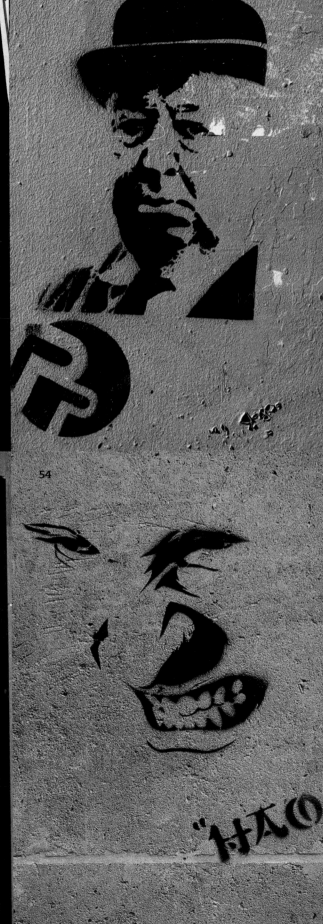

52

54

"HAO

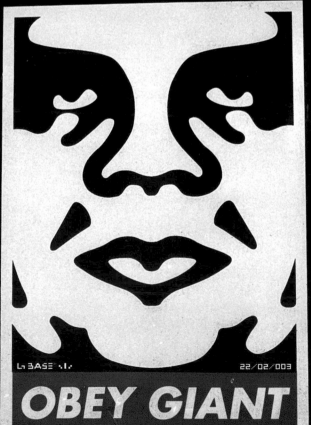

53

G BASE .1. 22/02/003

OBEY GIANT

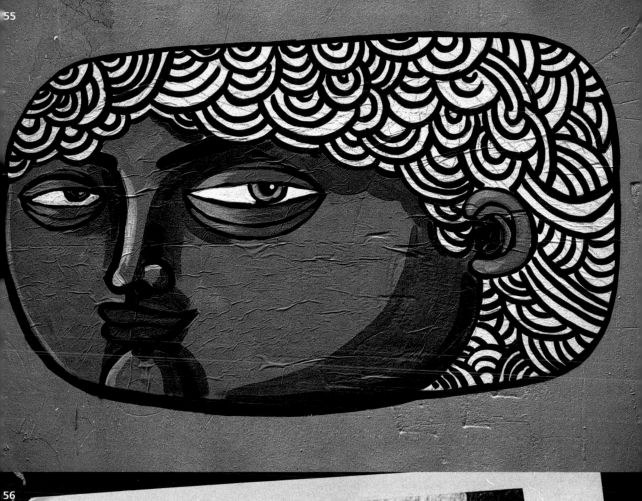

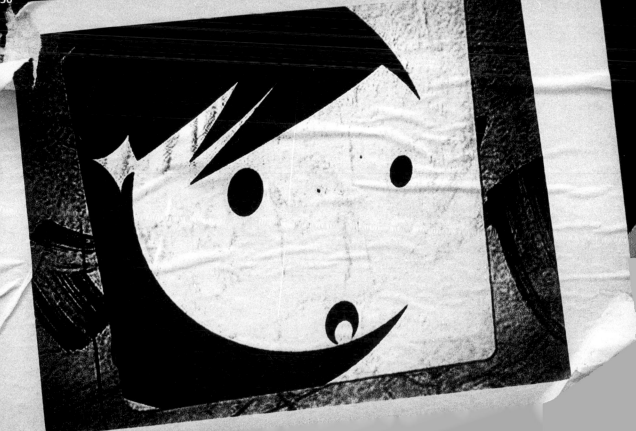

57

TRAVAIL CHOMAGE

TRAVAIL CHOMAGE

58

59

60

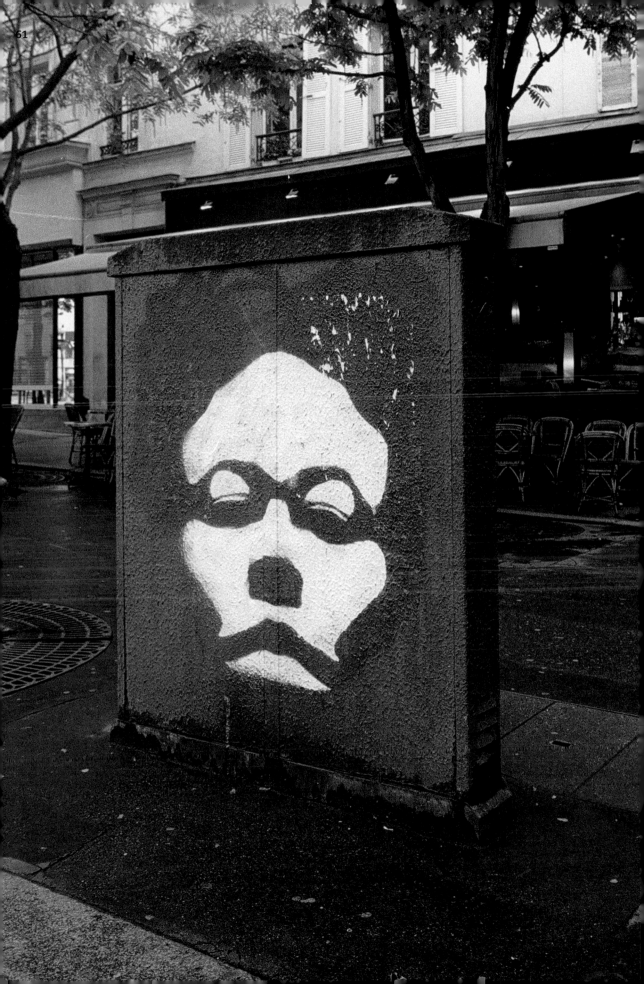

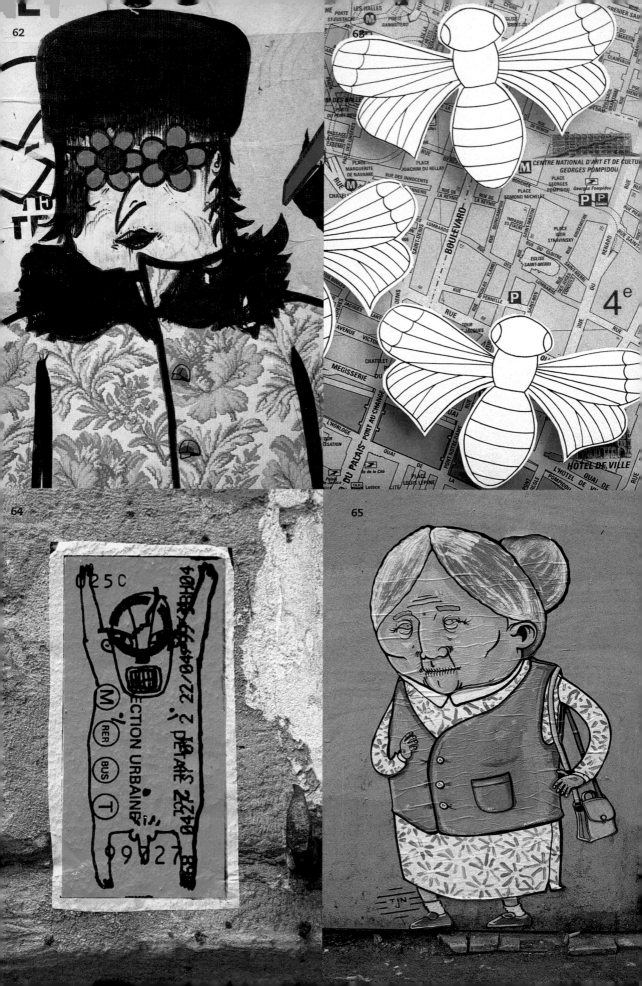

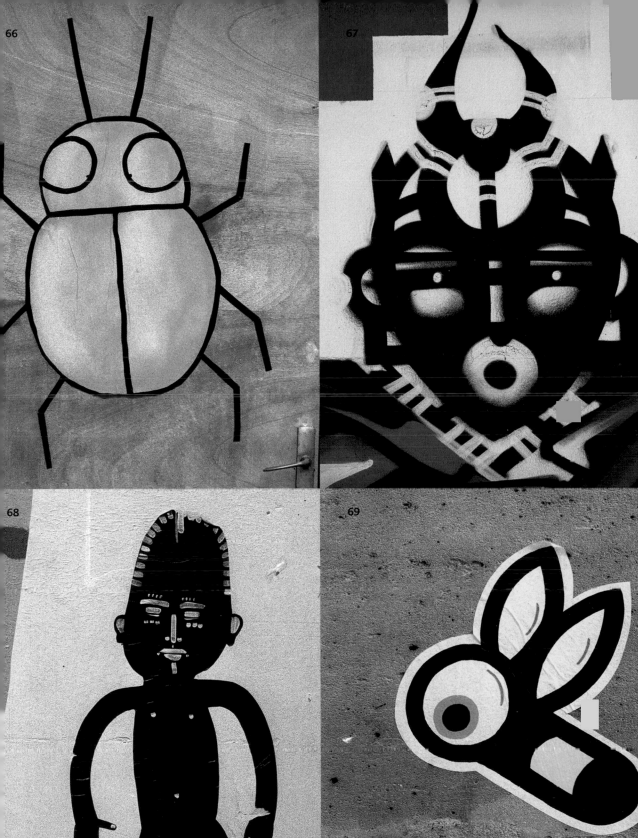

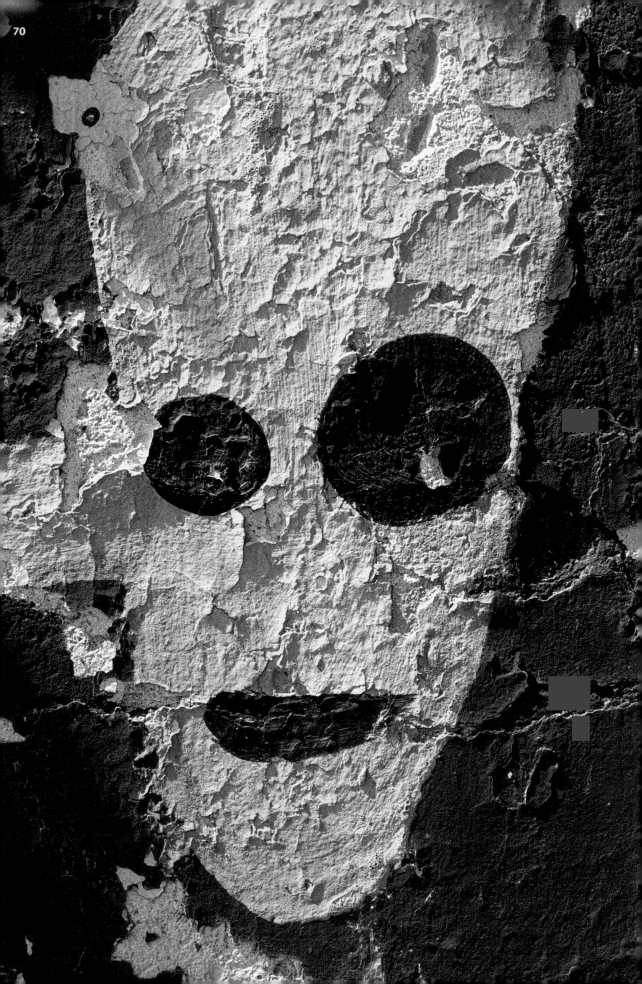

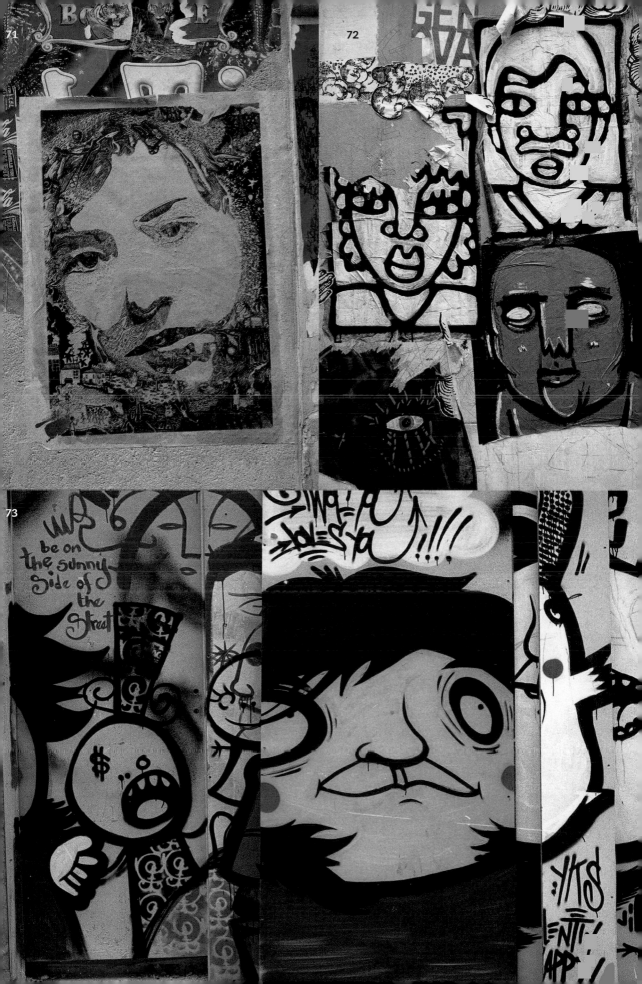

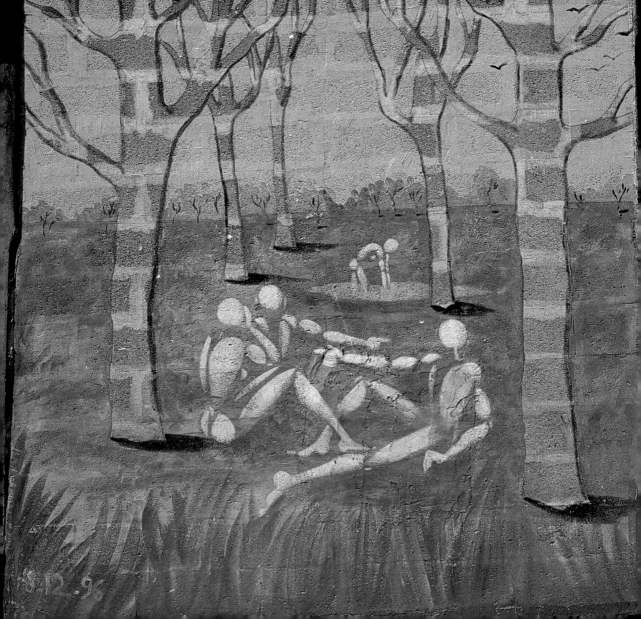

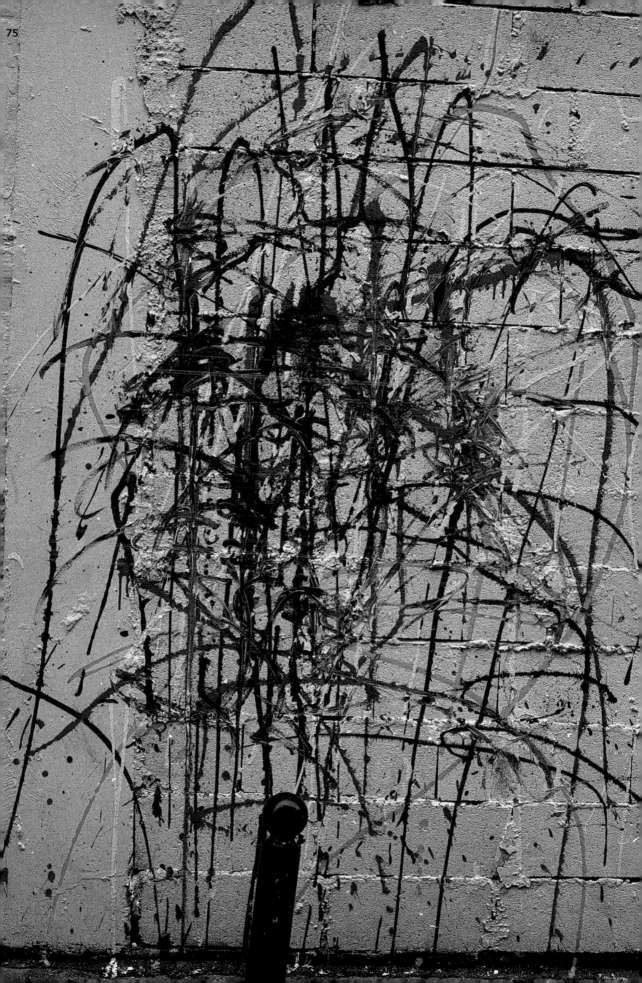

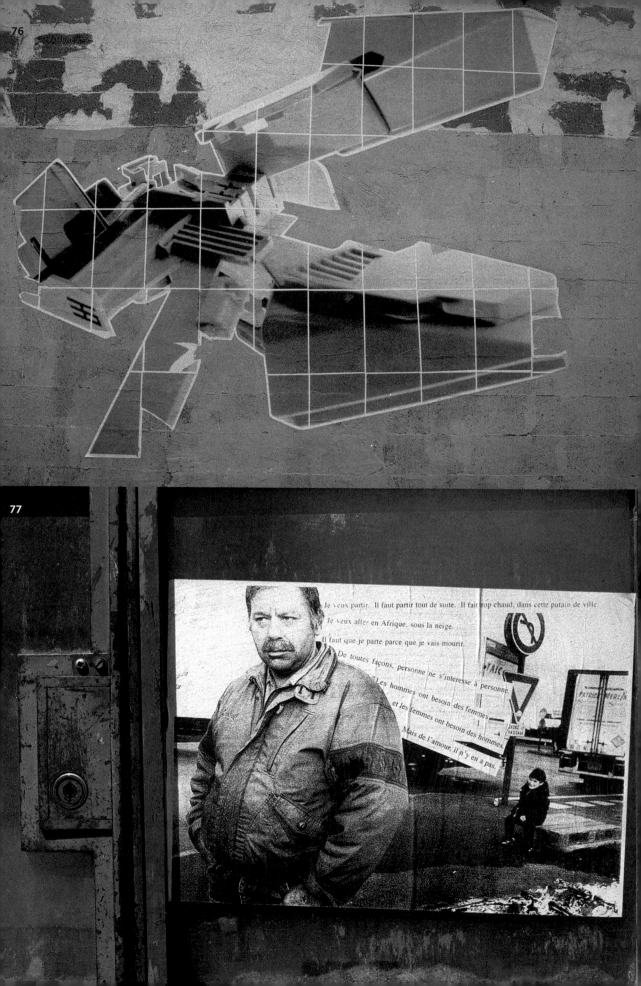

Je veux partir. Il faut partir tout de suite. Il fait trop chaud, dans cette putain de ville.
Je veux aller en Afrique, sous la neige.
Il faut que je parte parce que je vais mourir.
De toutes façons, personne ne s'intéresse à personne.
Les hommes ont besoin des femmes
et les femmes ont besoin des hommes.
Mais de l'amour, il n'y en a pas.

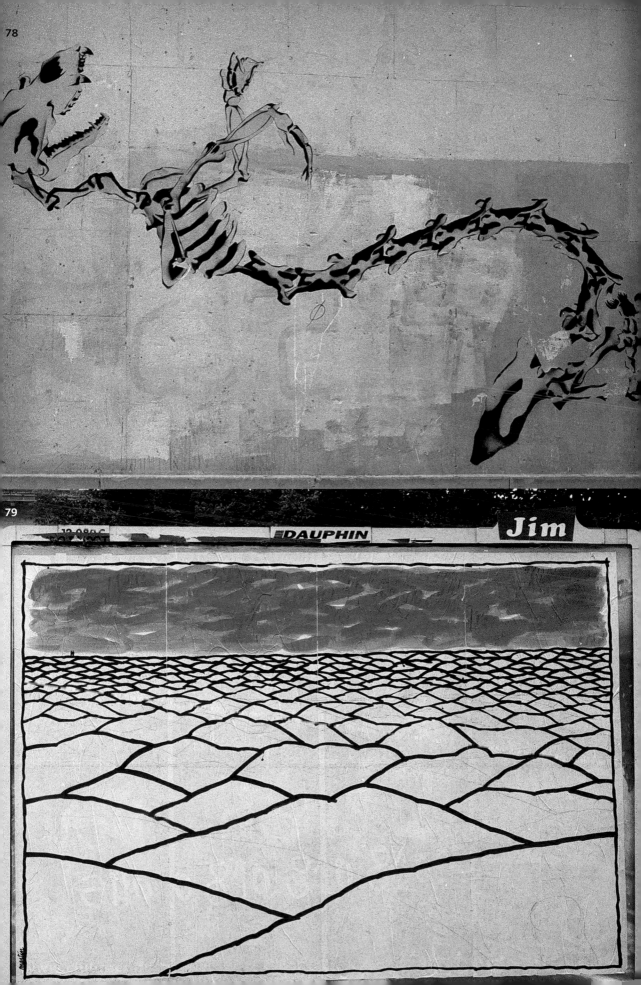

78

79

DAUPHIN

Jim

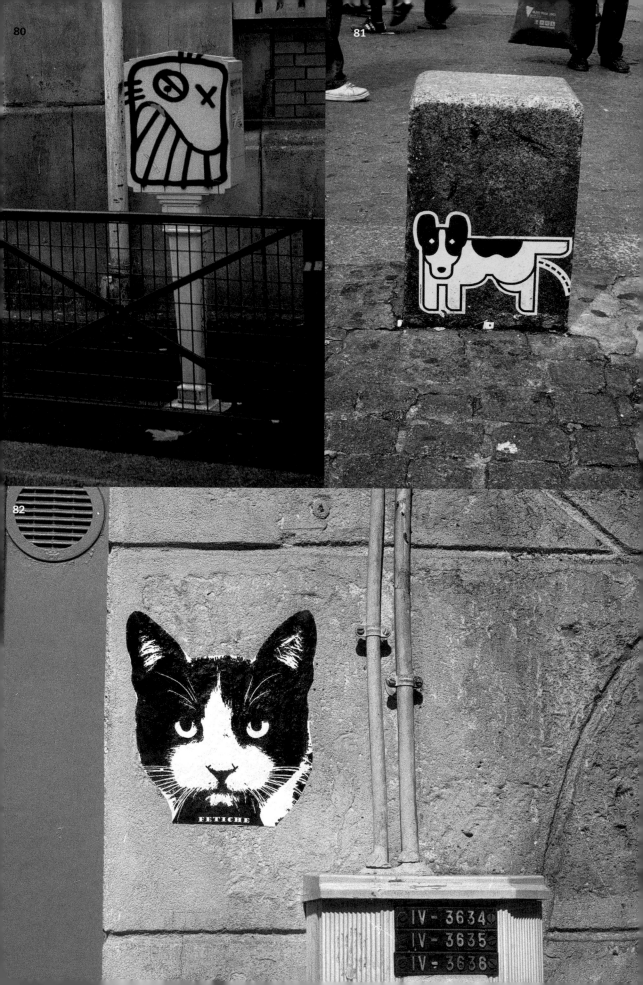

FETICHE

IV - 3634
IV - 3635
IV - 3636

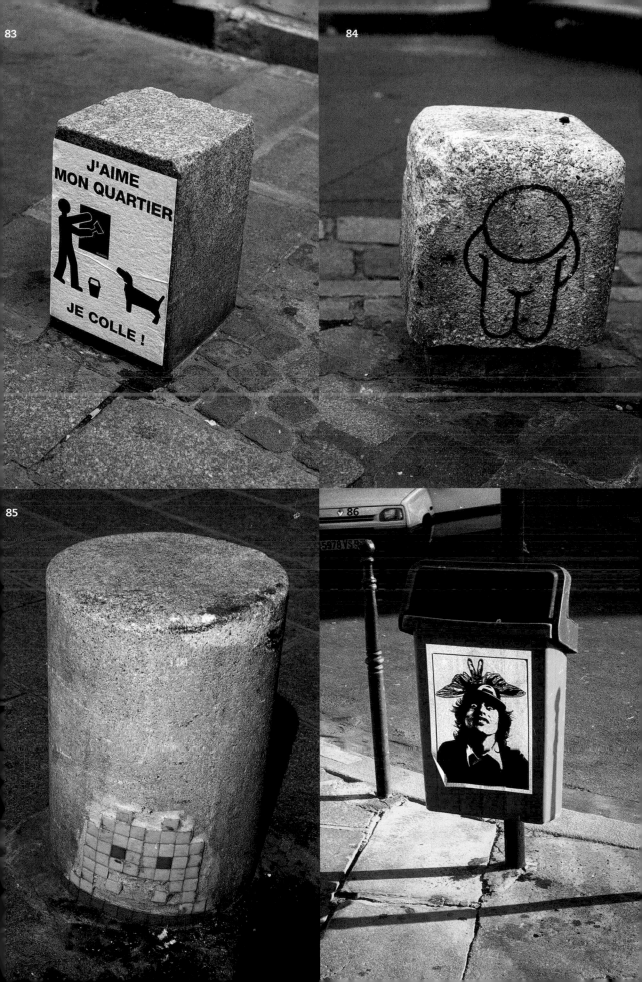

83

J'AIME
MON QUARTIER

JE COLLE !

84

85

86
5978 VS

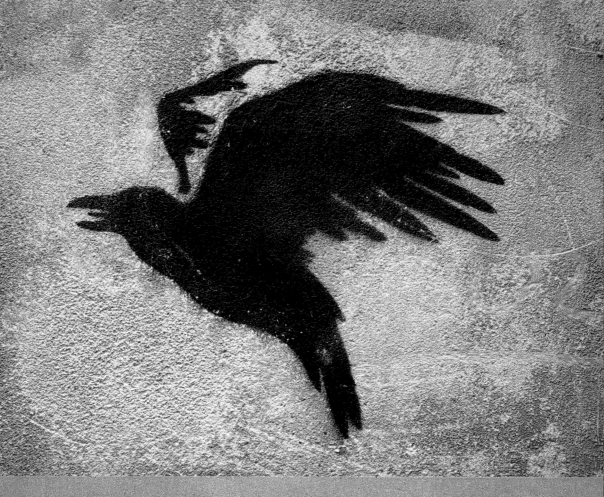

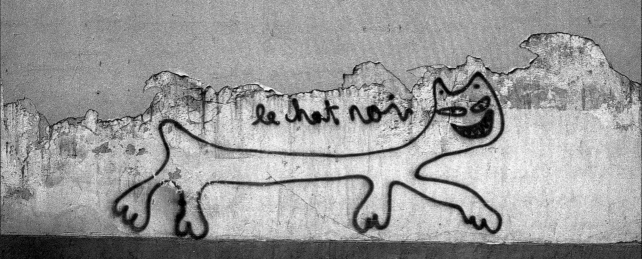

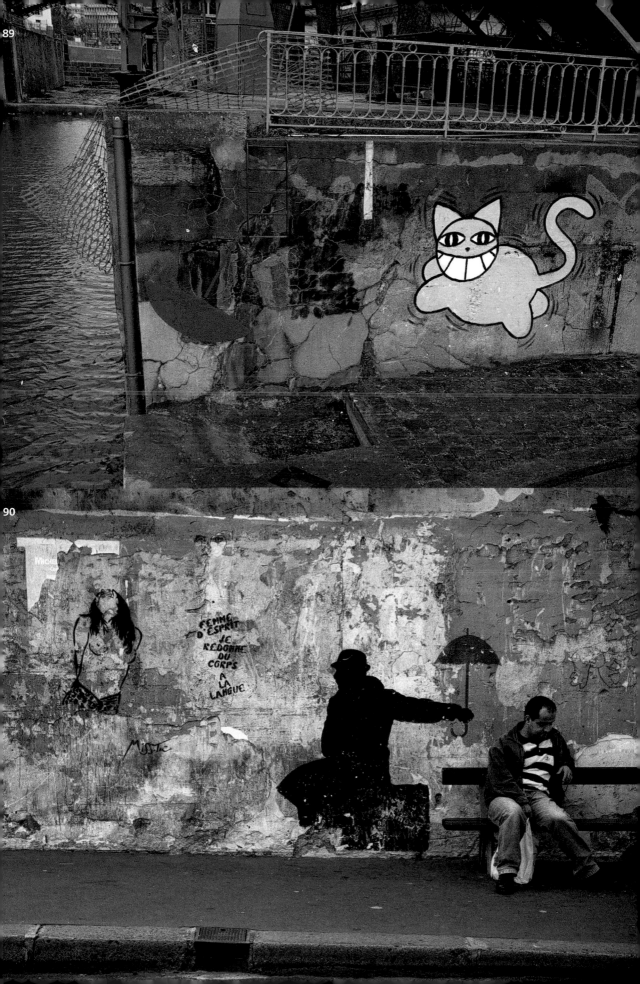

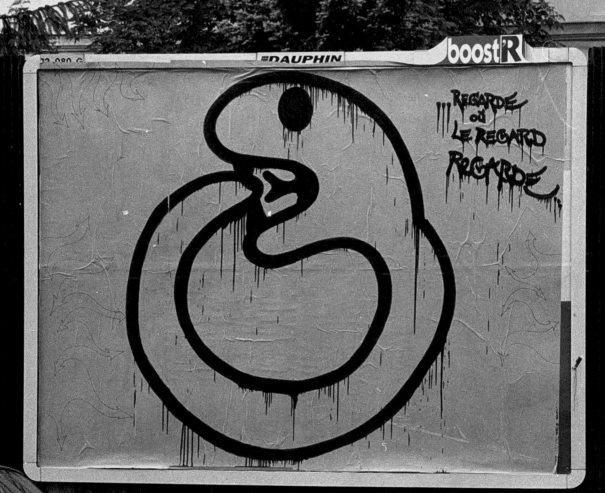

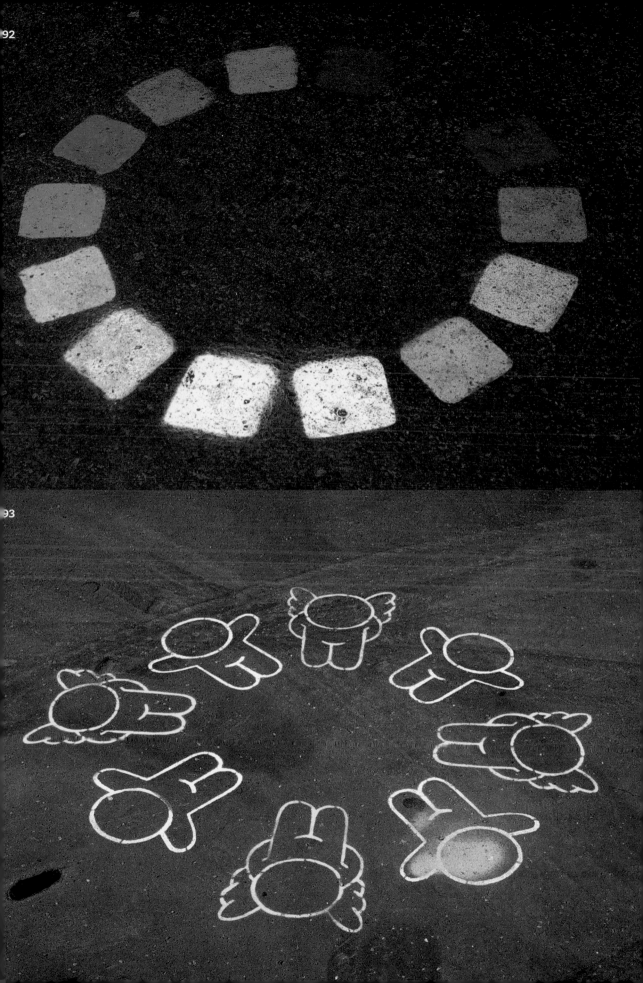

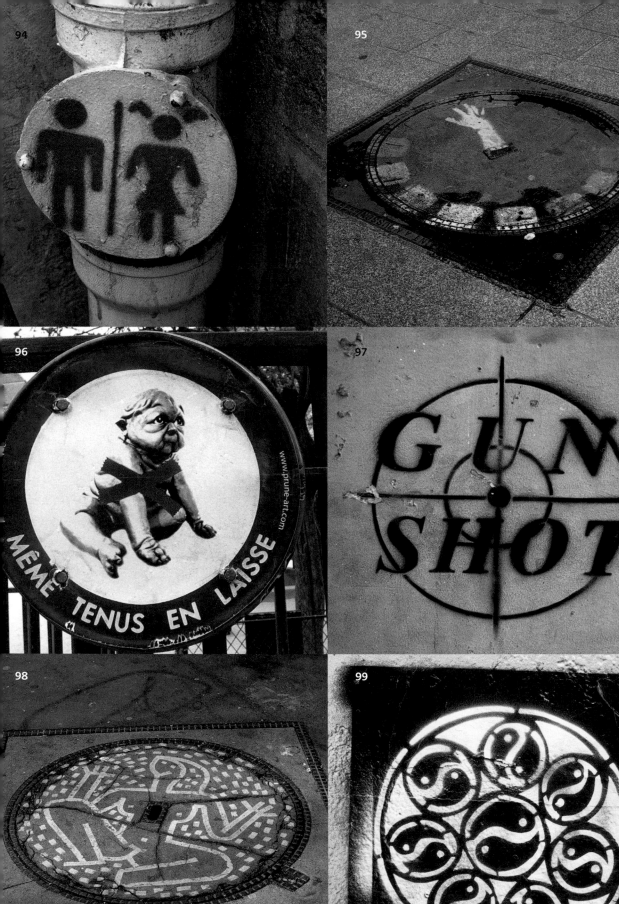

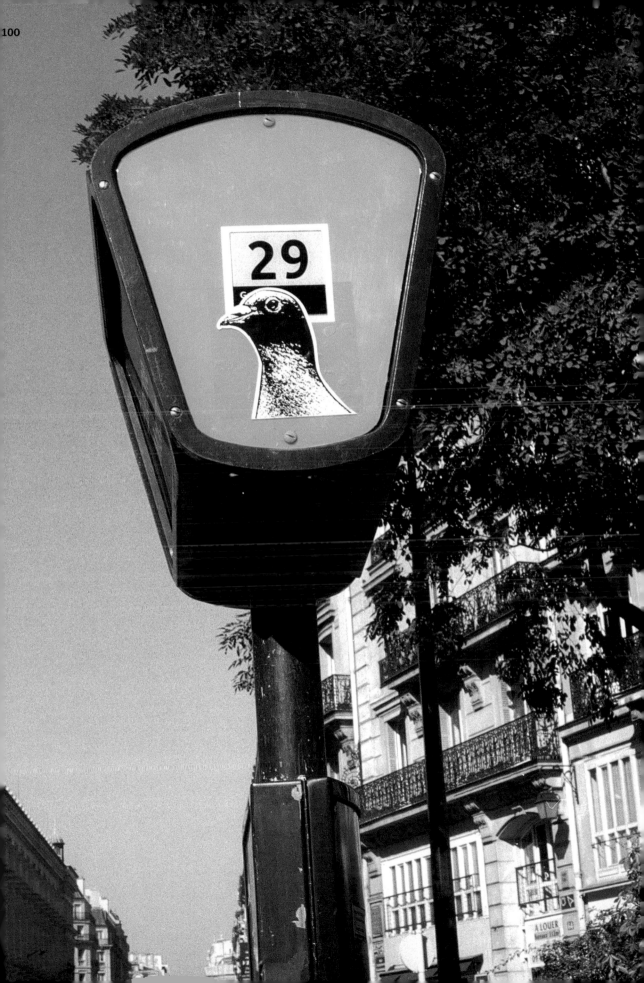

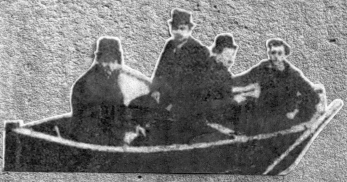

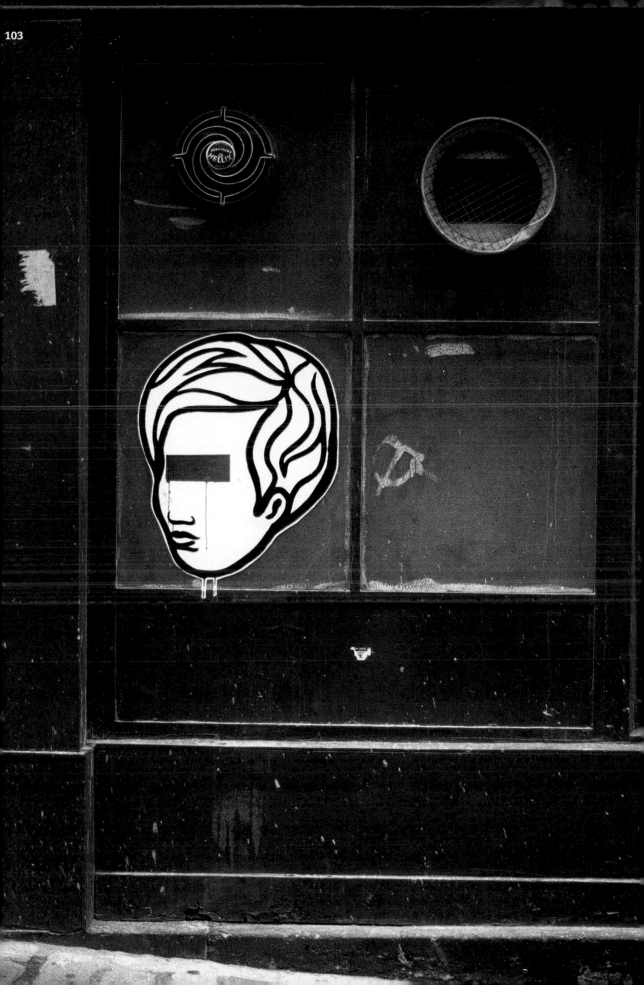

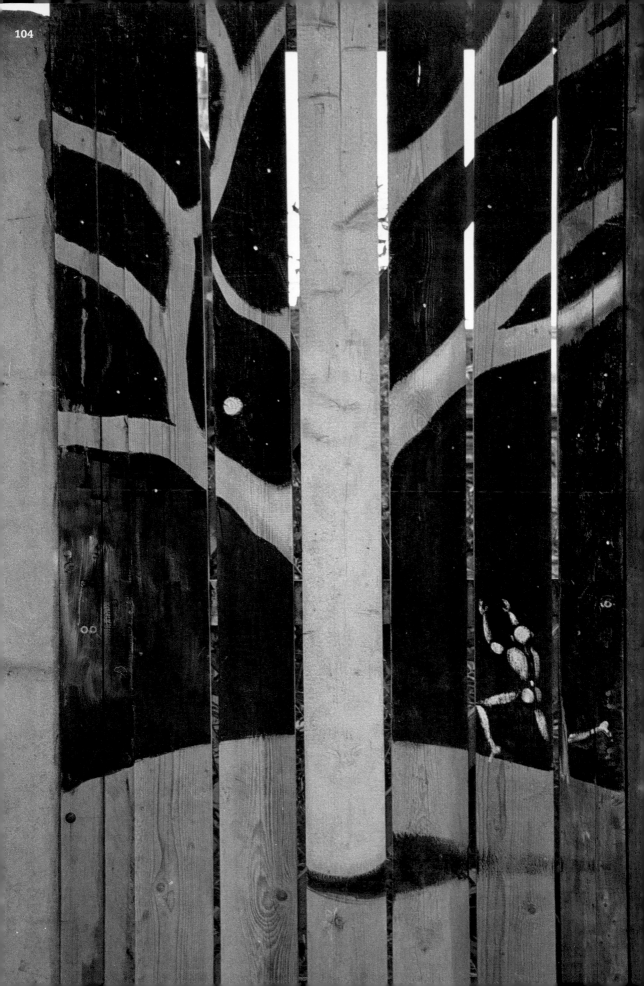

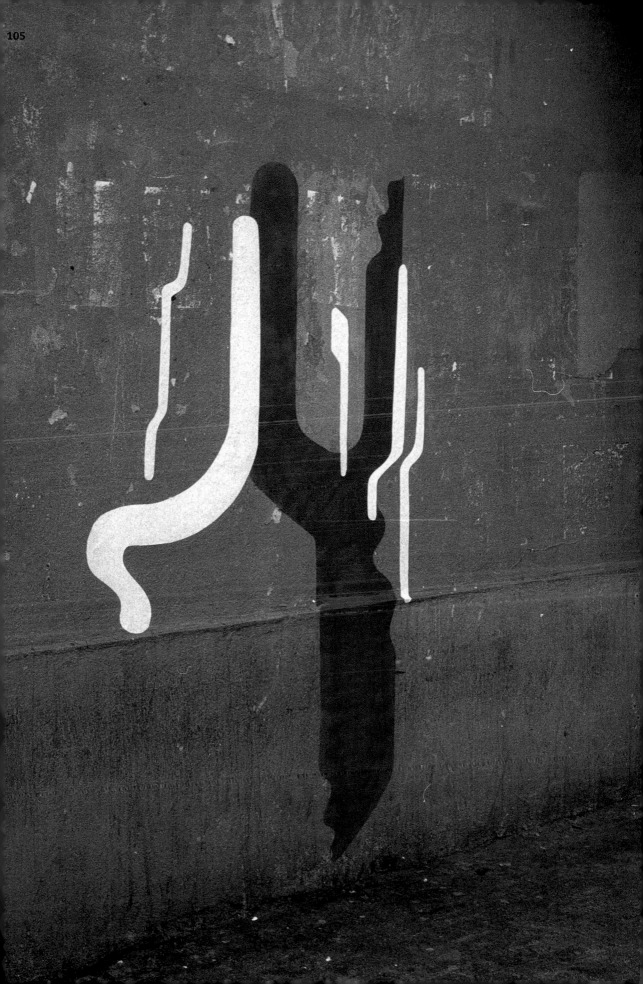

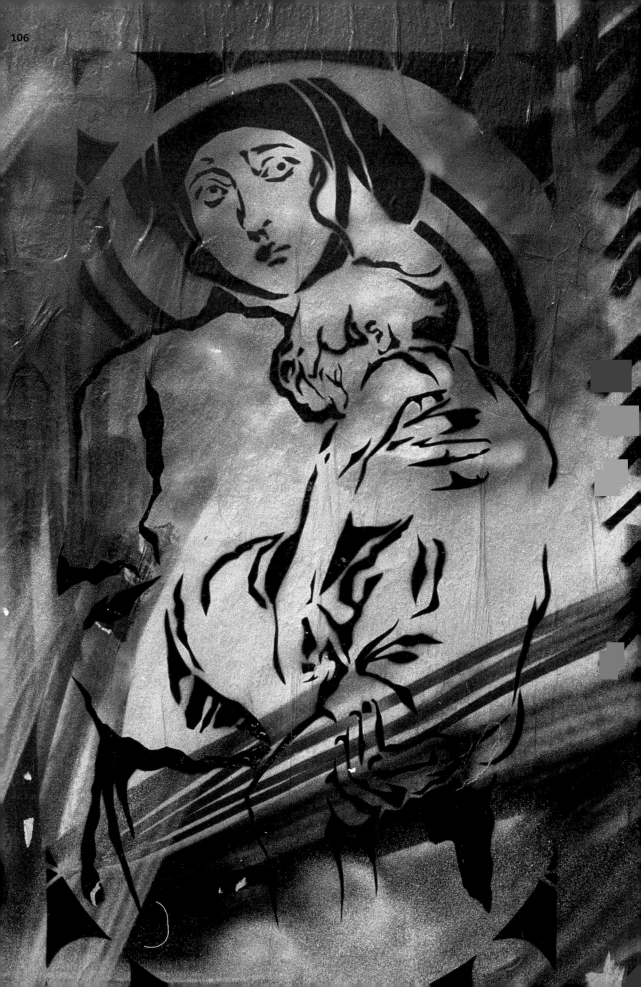

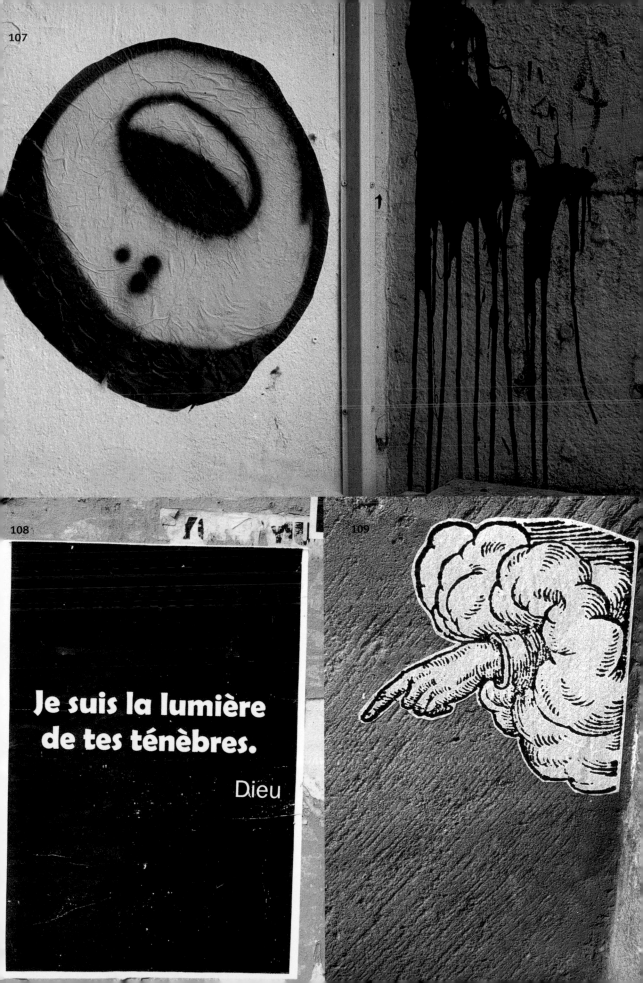

107

108

Je suis la lumière
de tes ténèbres.

Dieu

109

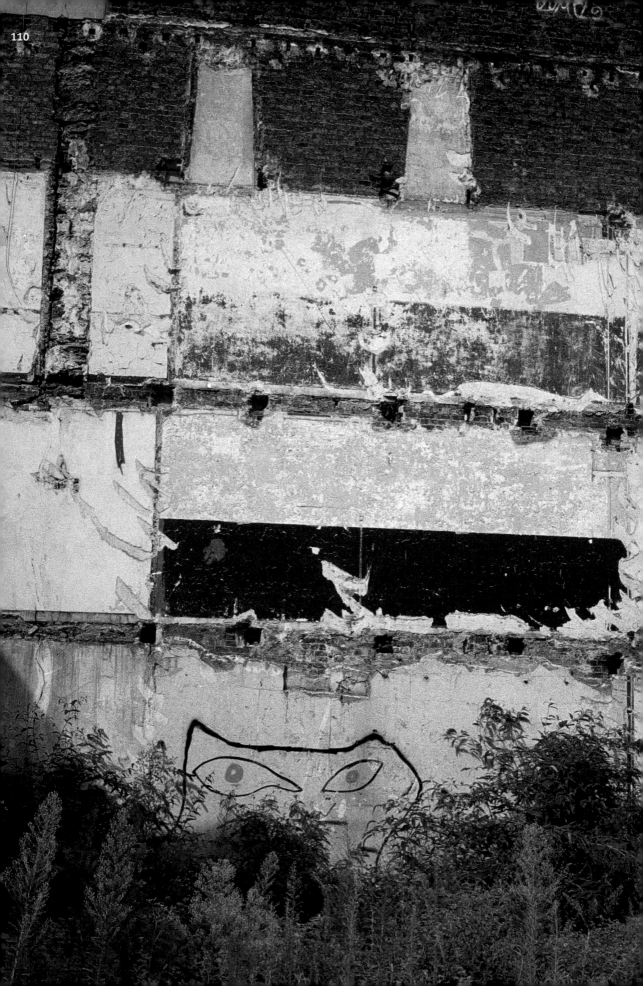

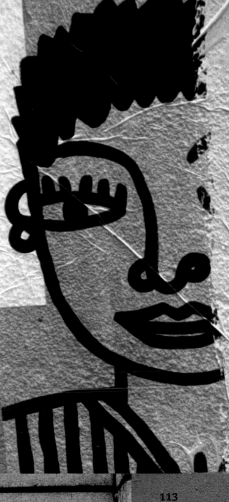

Pour Izis

Sur une palissade
dans un pauvre quartier
des affiches mal collées
Grand Bal du Printemps
illuminent
l'ombre à un arbre décharné
et celle d'un réverbère pas encore allumé

Devant ces petites annonces de la vie
un passant s'est arrêté
émerveillé

C'est un colporteur d'images
et même sans le savoir
un musicien ambulant
qui joue à sa manière
surtout en hiver
le Sacre du Printemps
Et c'est toujours le même air
intense et bouleversant
pour tempérer l'espace
pour espacer le temps
Toujours le portrait des choses et des êtres
qui l'ont touché

JE SUIS UN MORCEAU D'UTOPIE

VLP

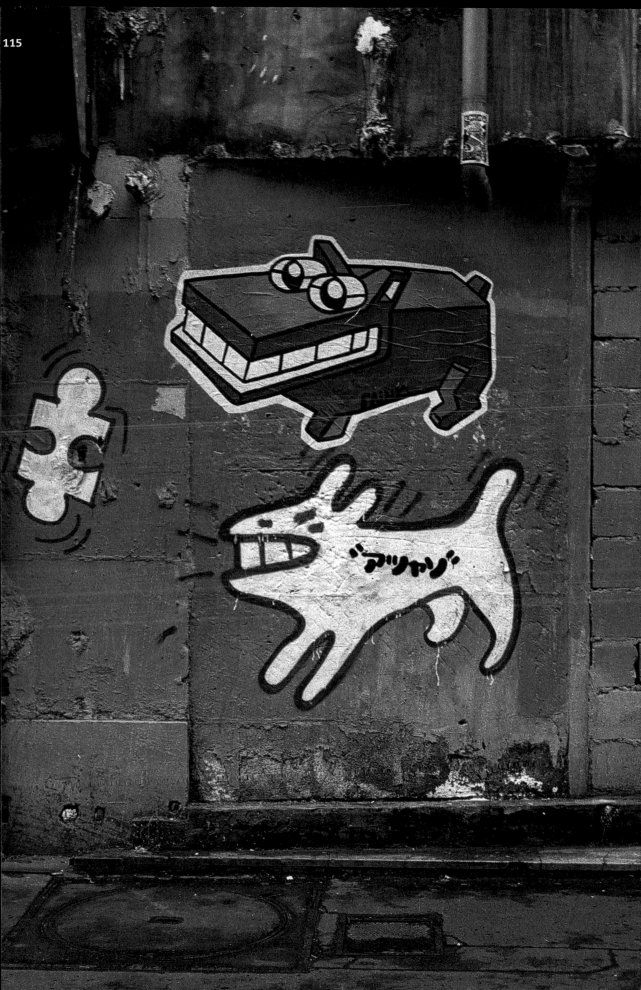

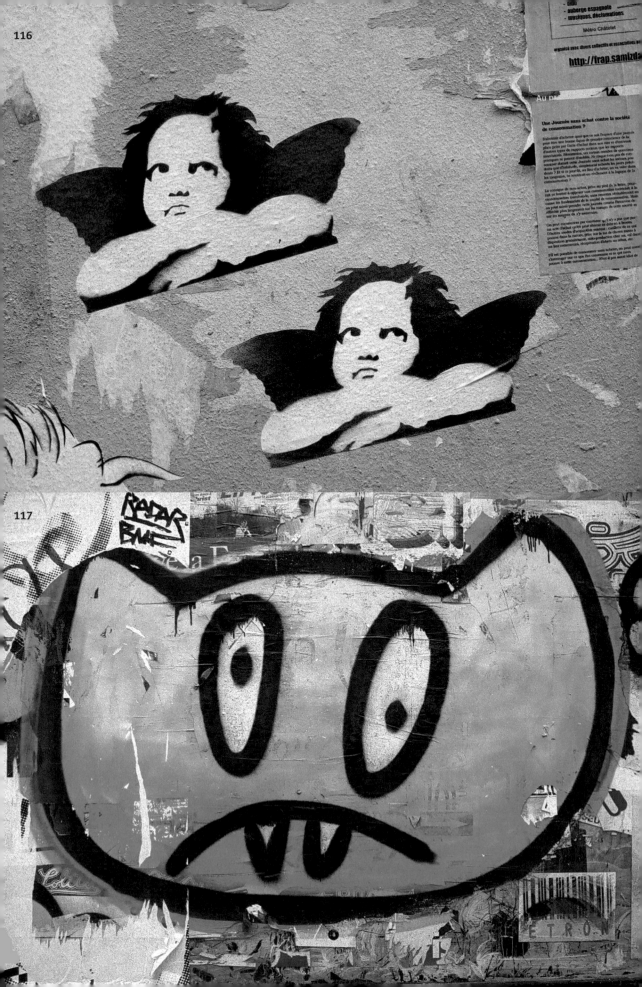

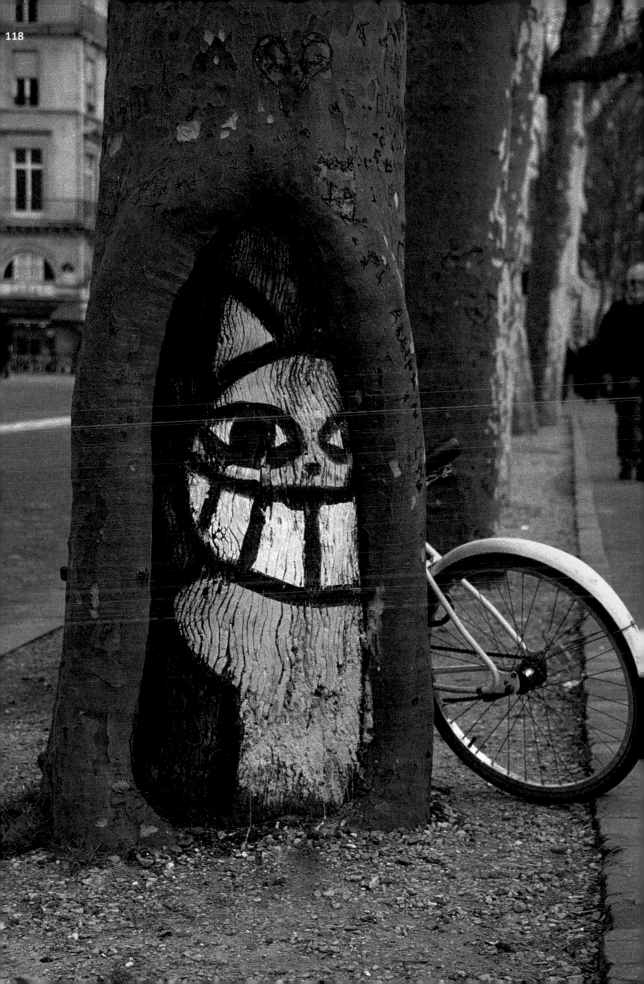

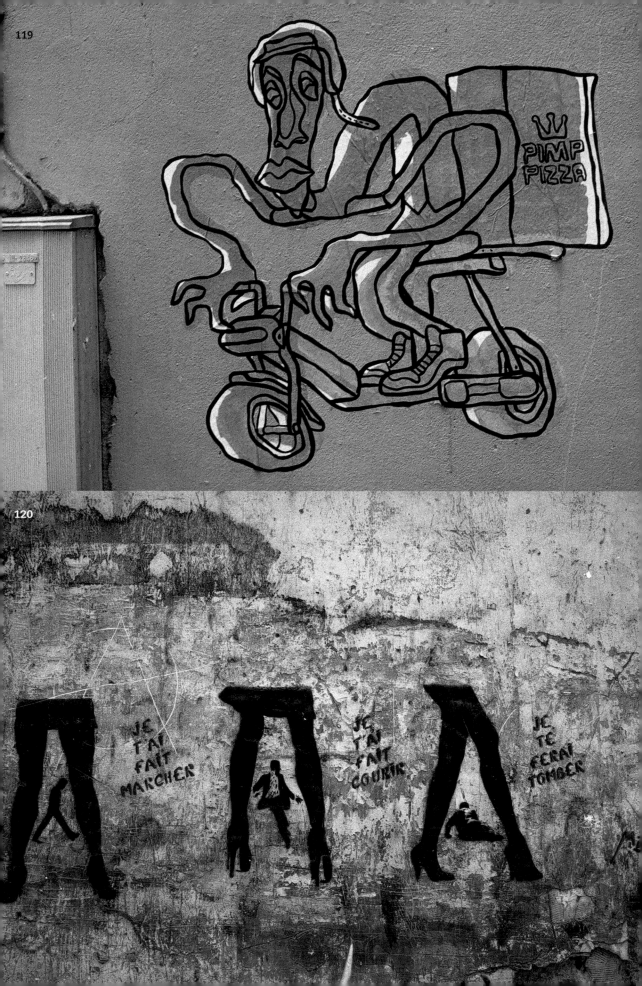

121

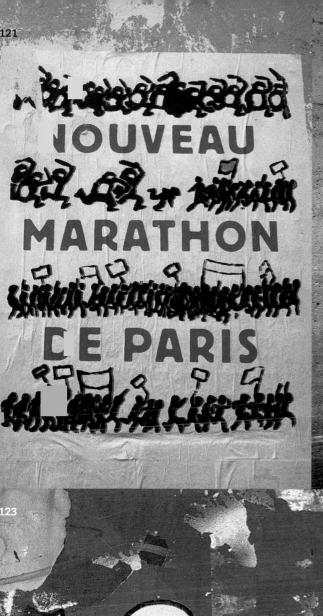

NOUVEAU

MARATHON

DE PARIS

122

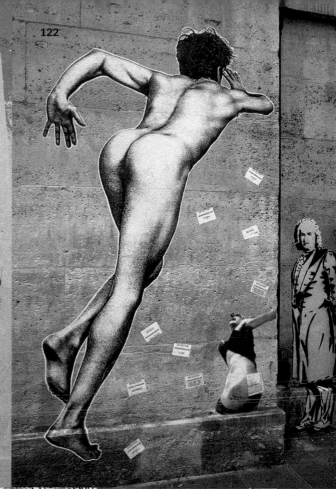

123

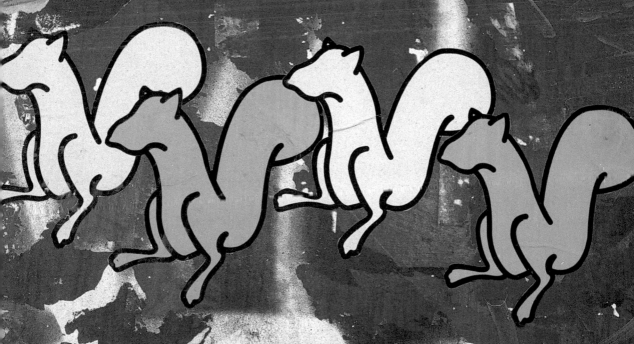

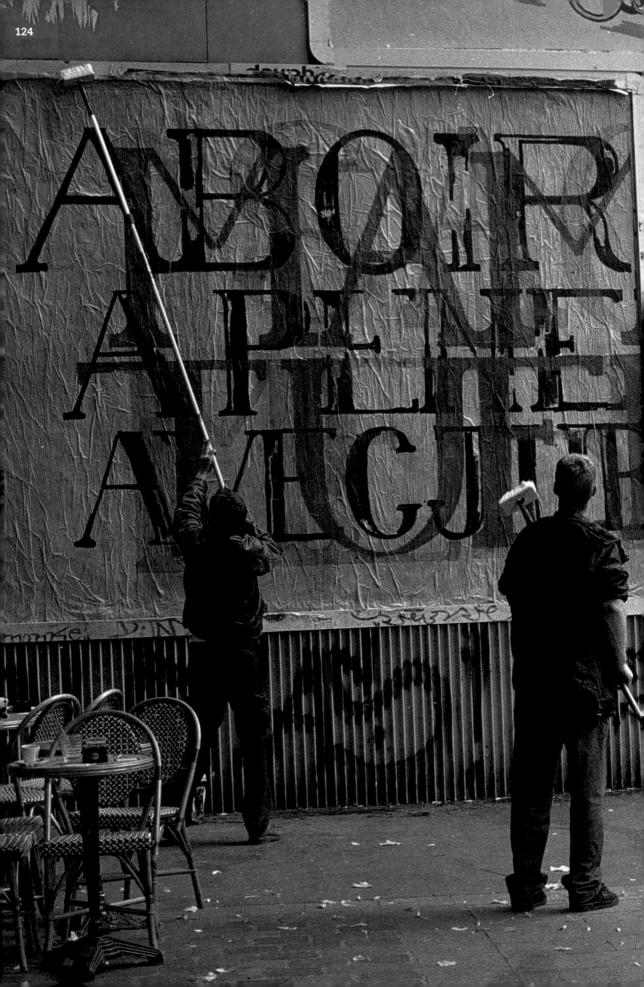

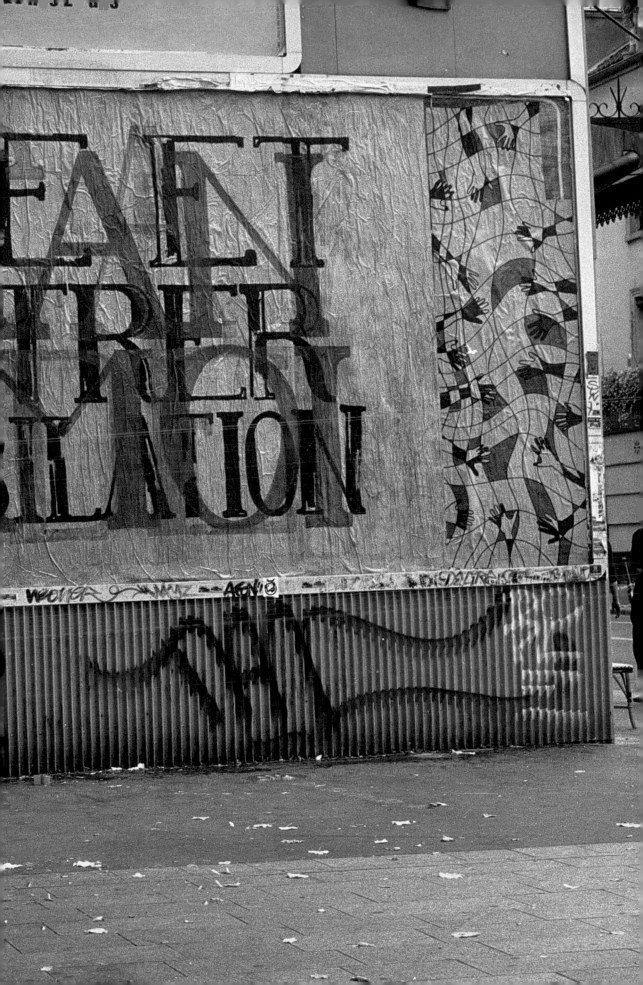

125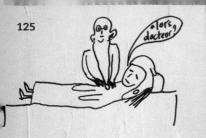

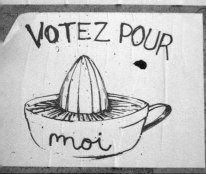

126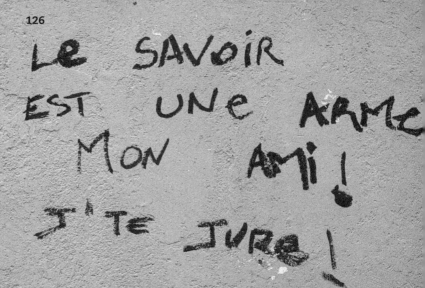

127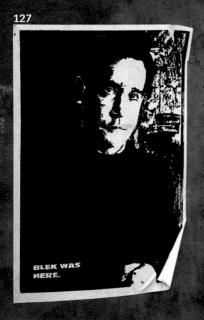

128

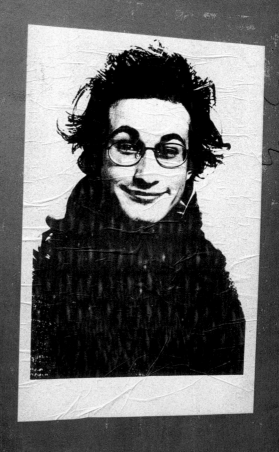

129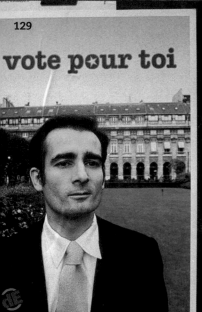

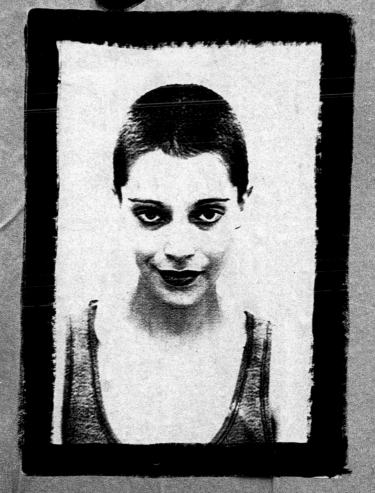

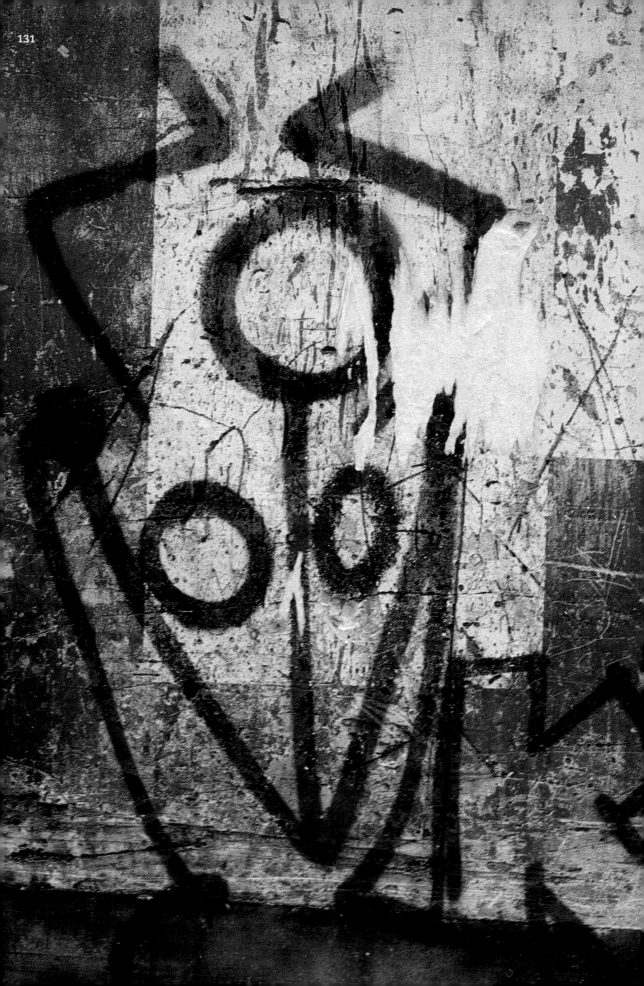

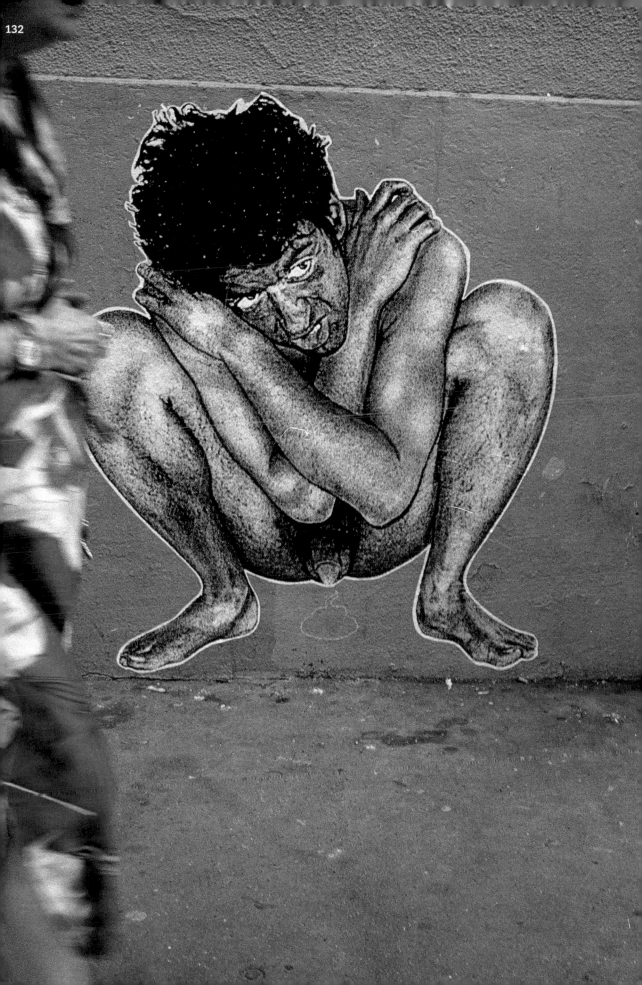

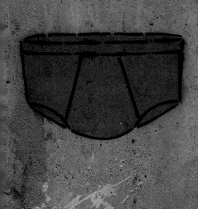

133

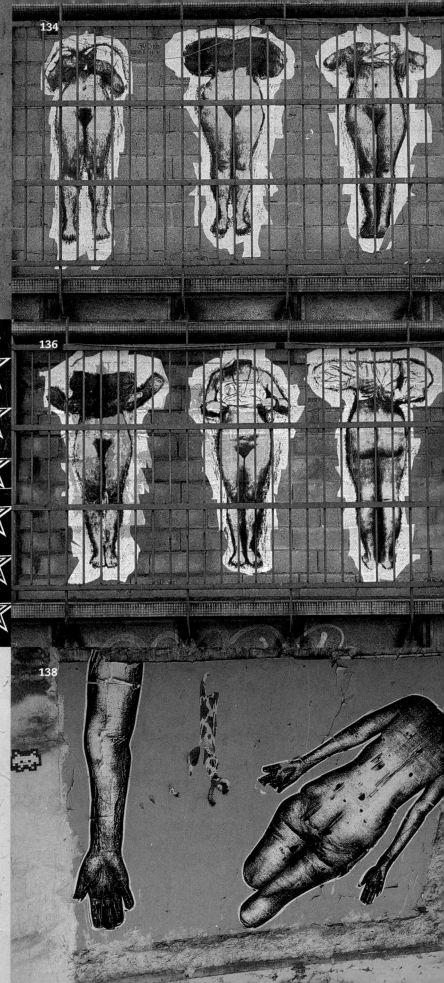

134

136

138

135

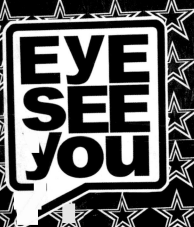

EYE SEE YOU

137

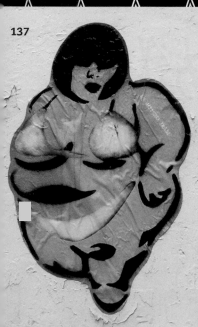

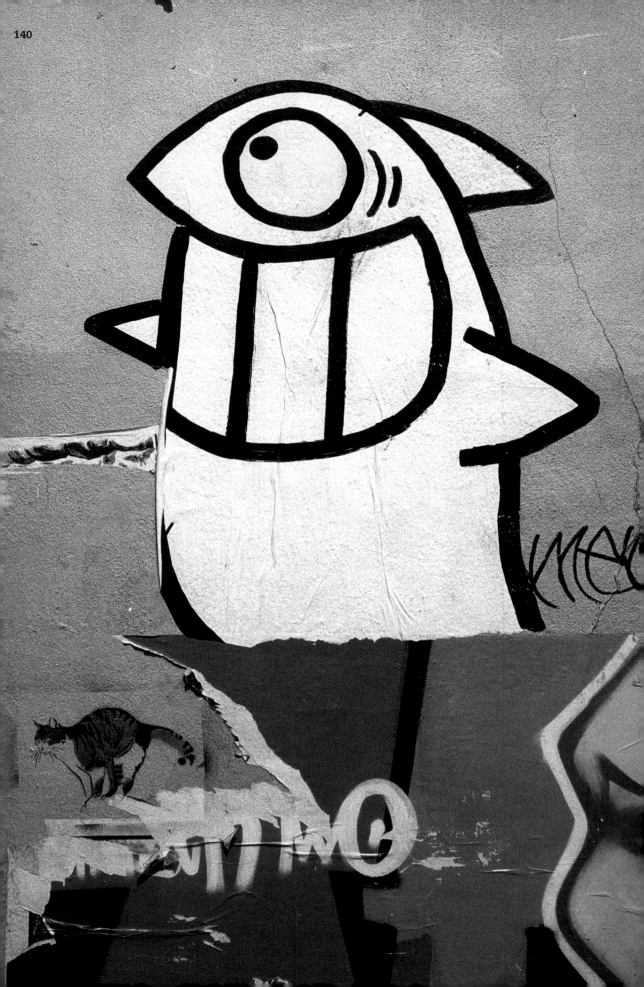

141

142

143

144

145

E

S

GAZ

W

O

ATLANTIQUE
6/10
7° 29" NORD
47° 5" OUEST

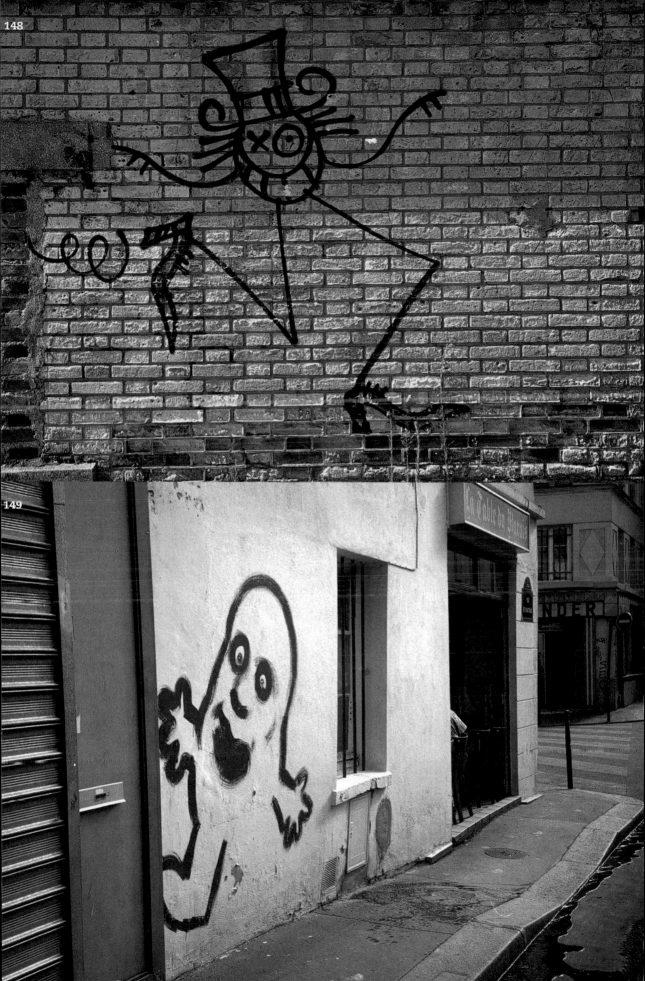

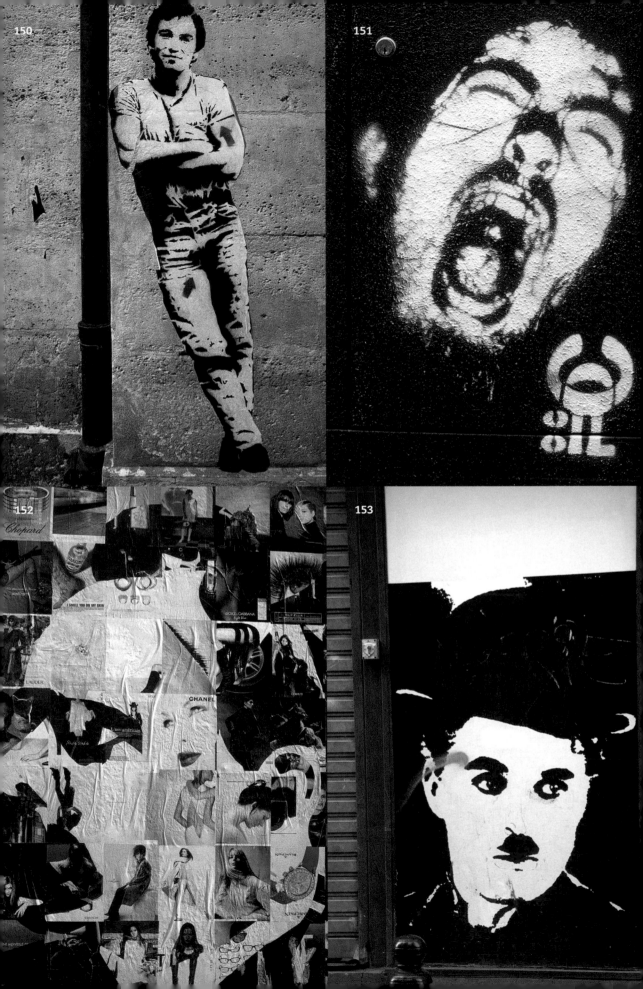

150

151

152

153

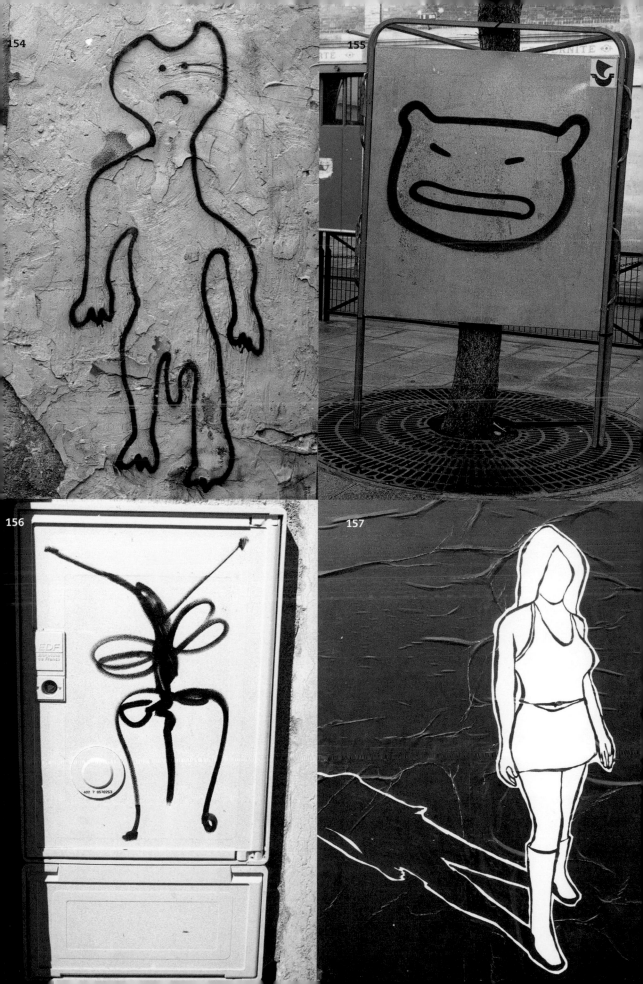

158

159

160

161

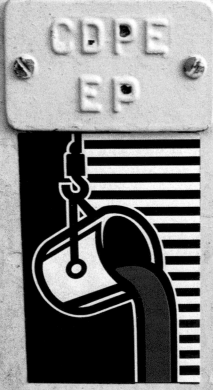

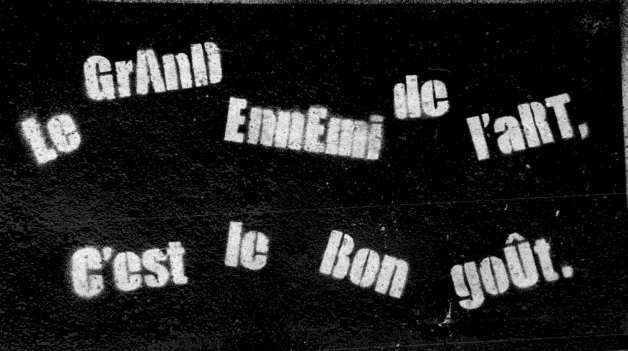

Le GrAnD EnnEmi de l'aRT,

C'est le Bon goût.

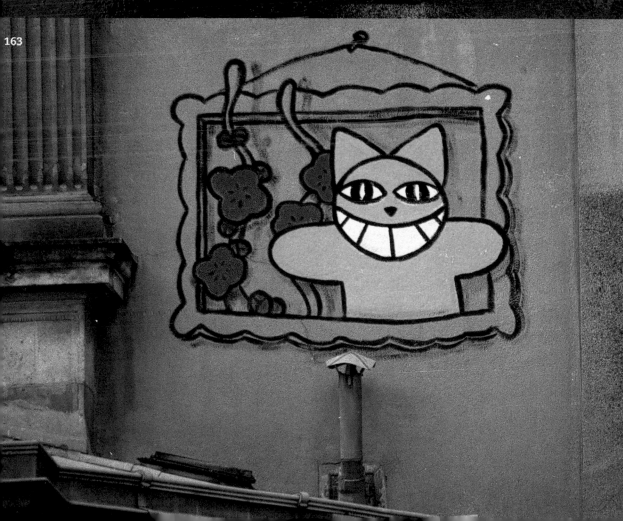

164

SPEEDY GRAPHITO

léZarts de la bièvre

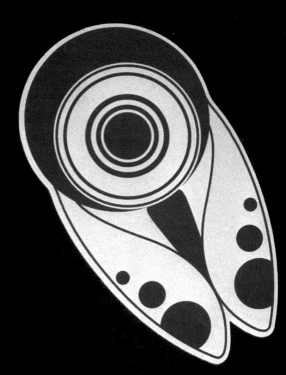

165

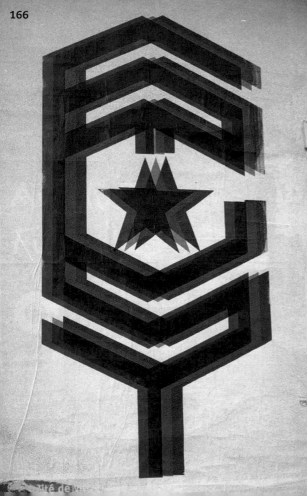

166

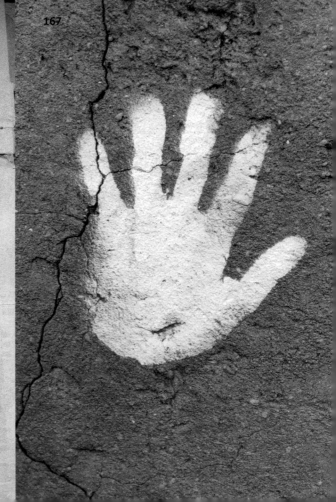

167

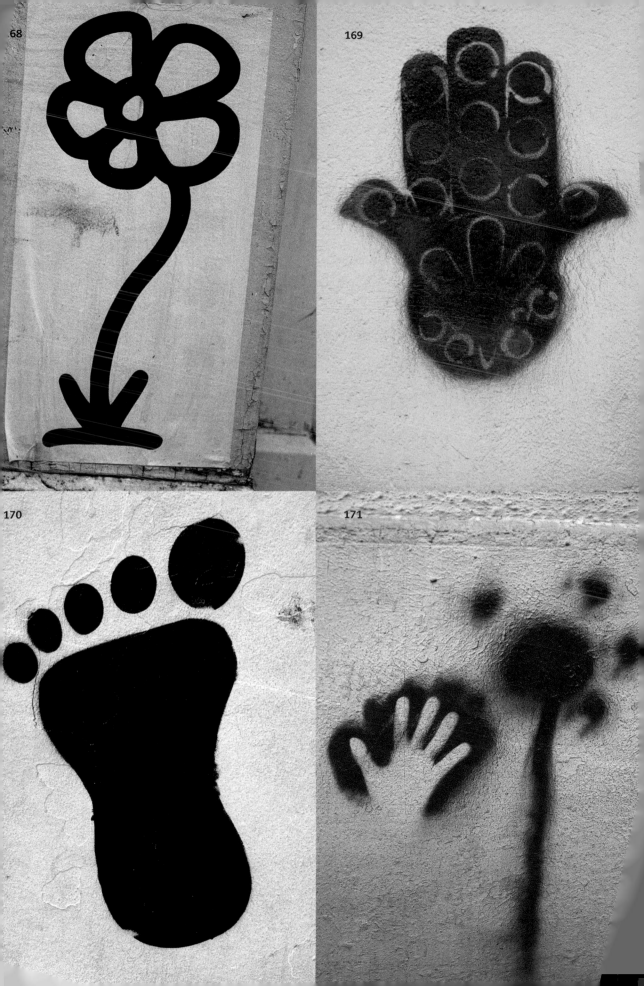

68

169

170

171

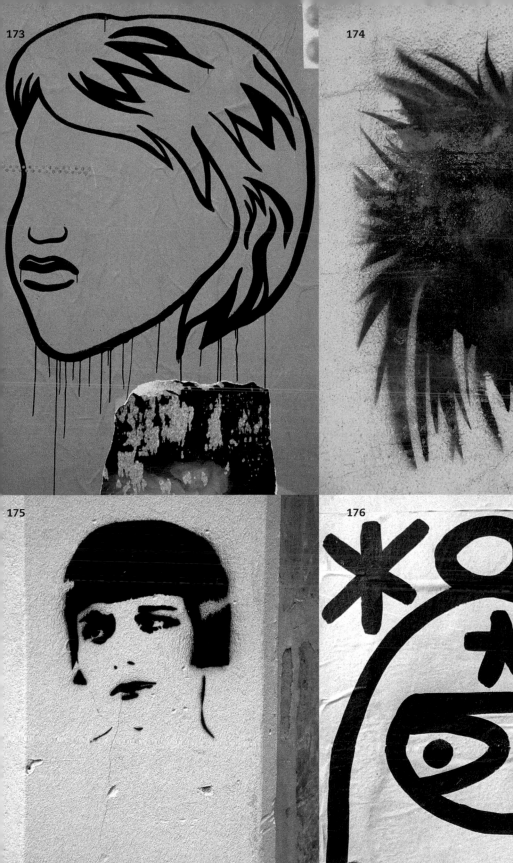

173

174

175

176

LASZLO

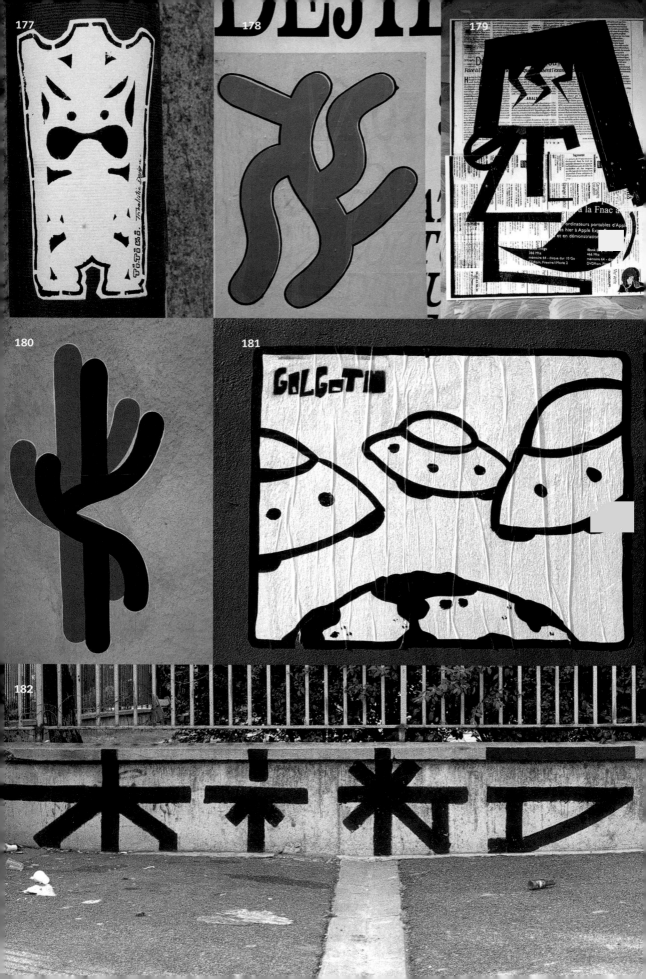

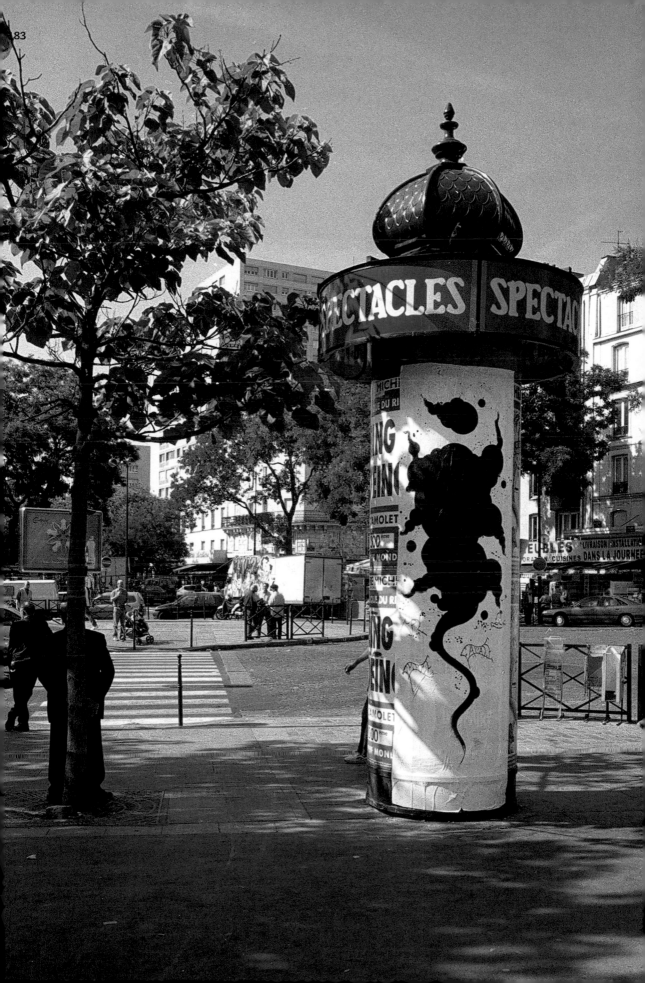

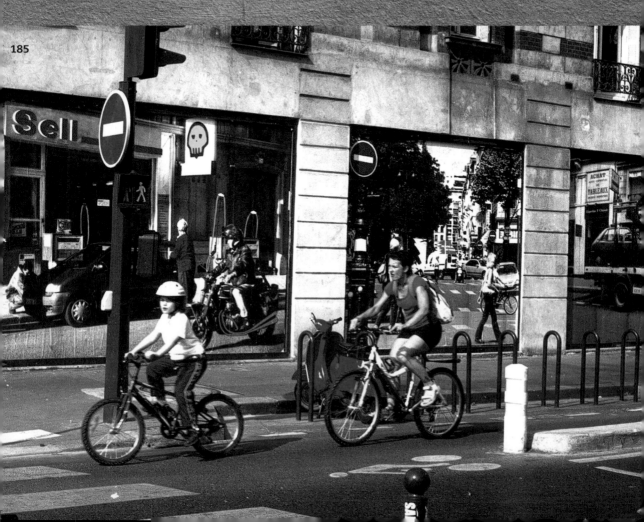

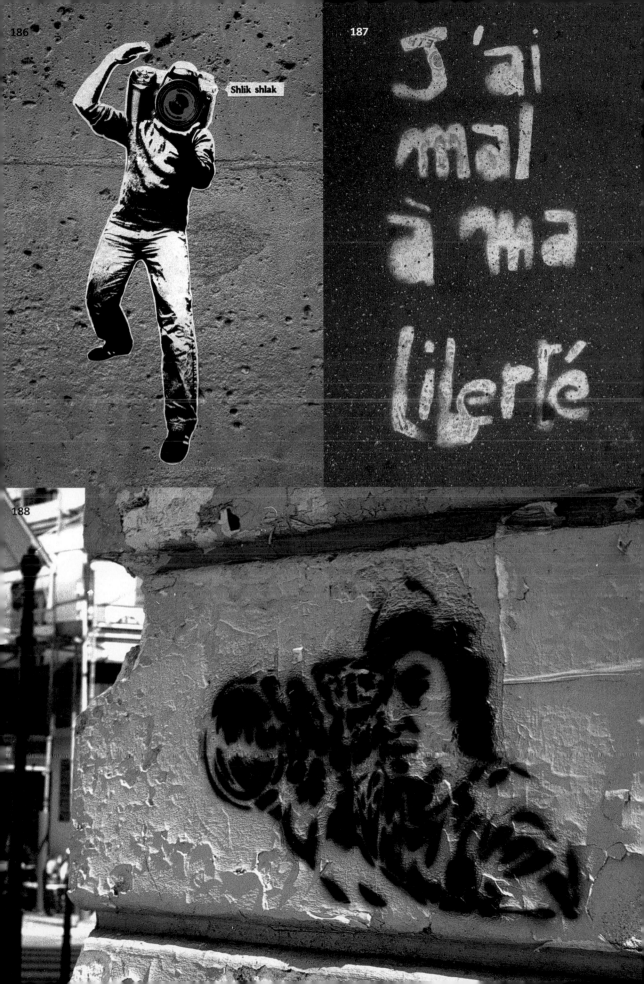

Shlik shlak

J'ai mal à ma liberté

189

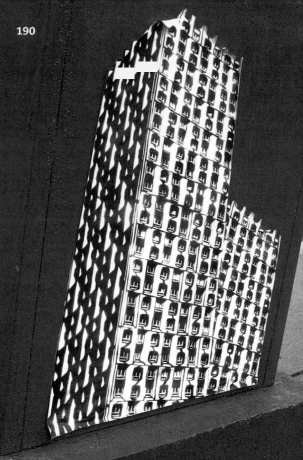

190

191

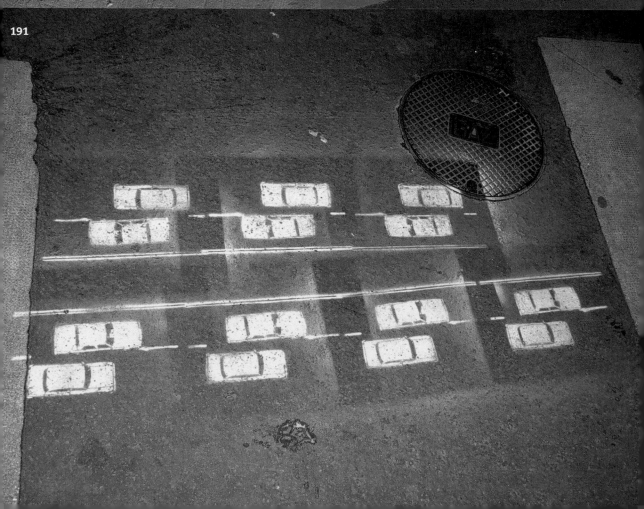

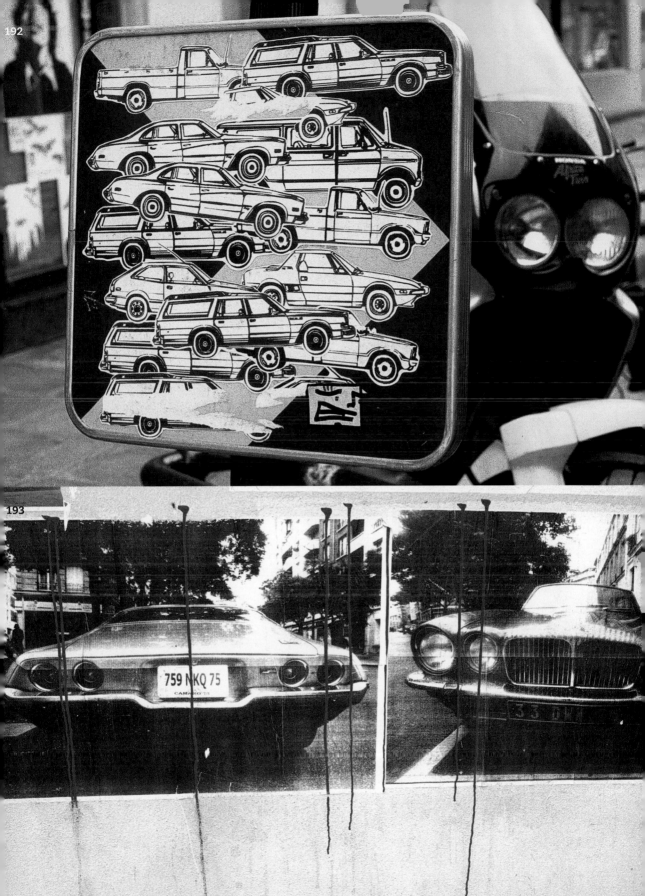

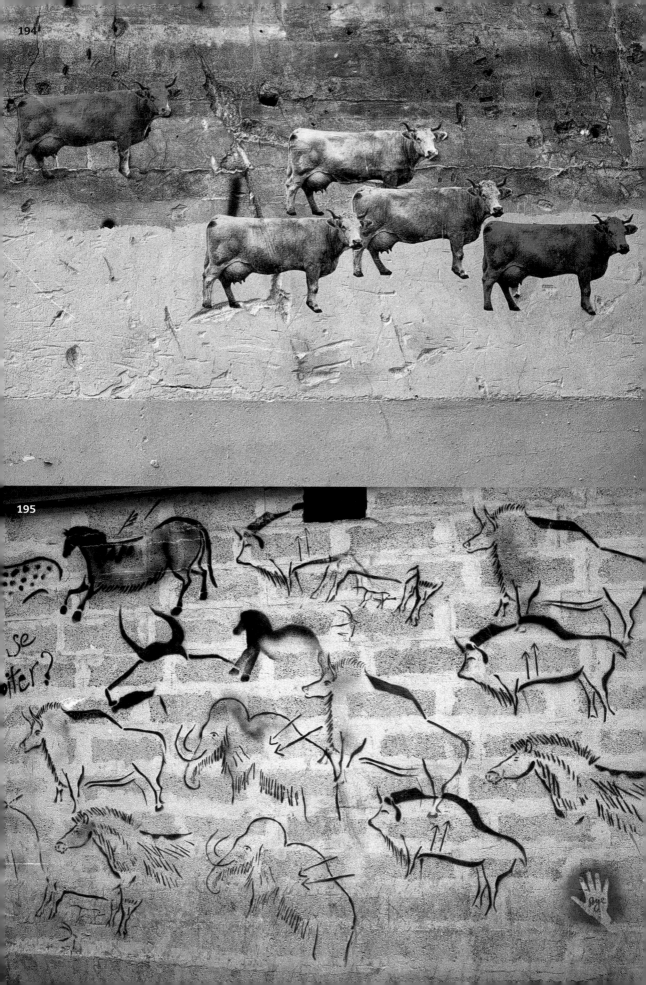

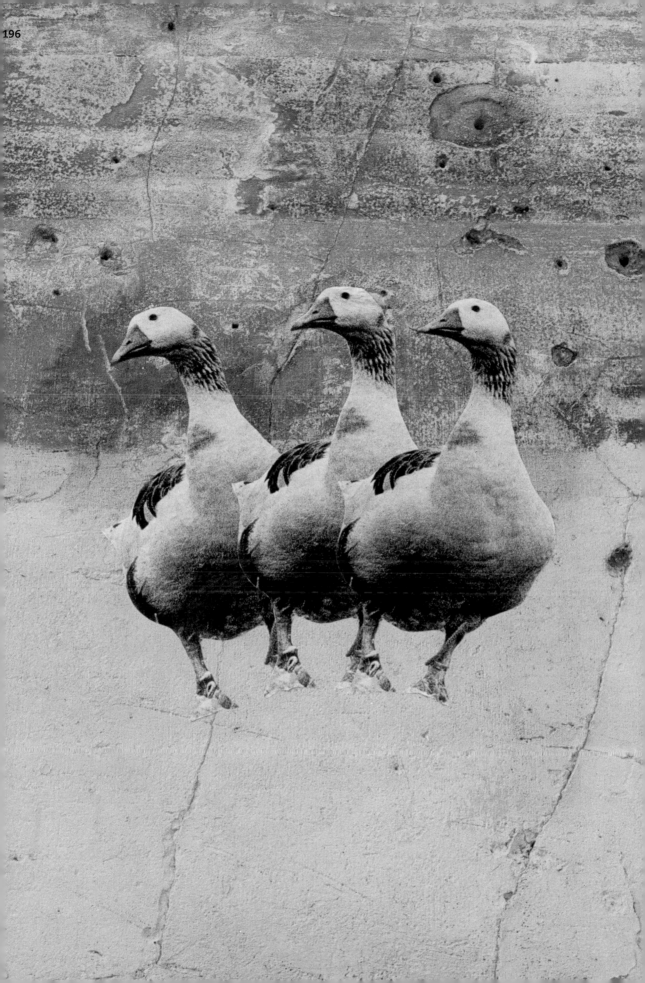

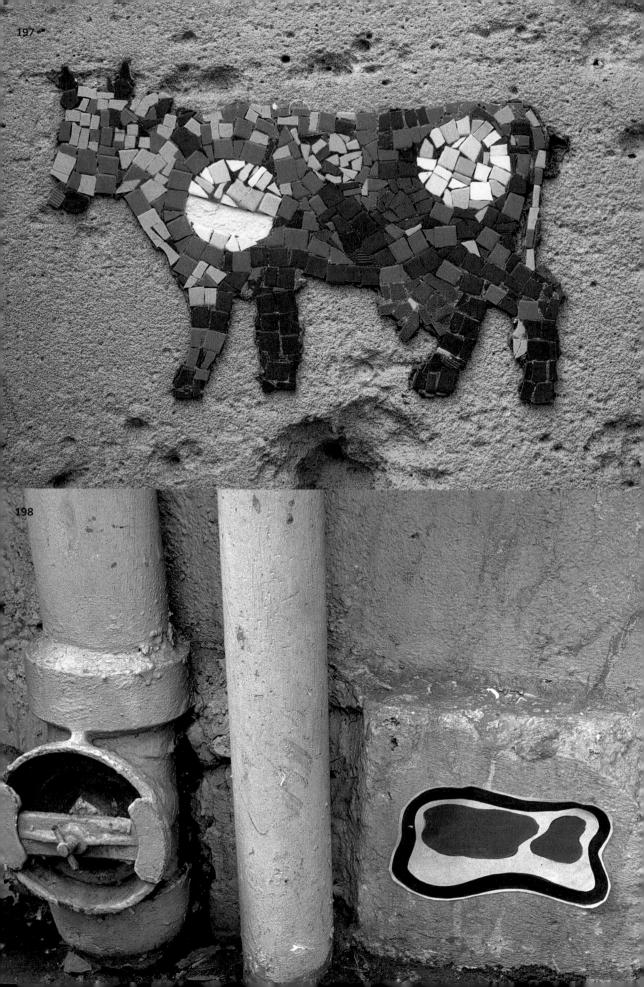

197

198

199

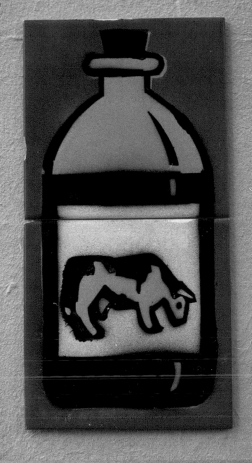

200

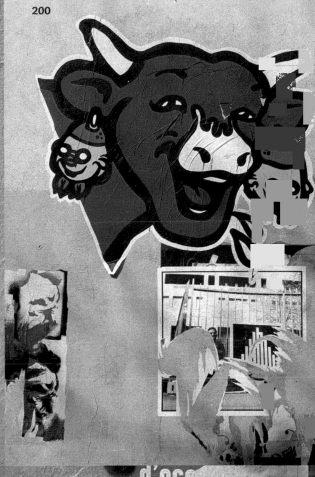

201

202

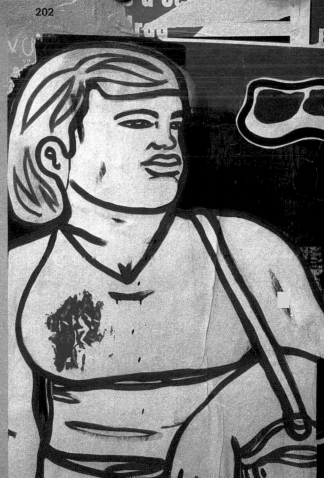

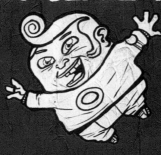
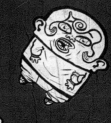

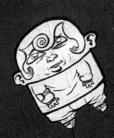

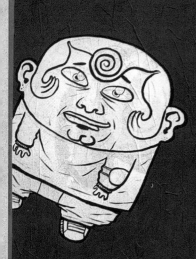

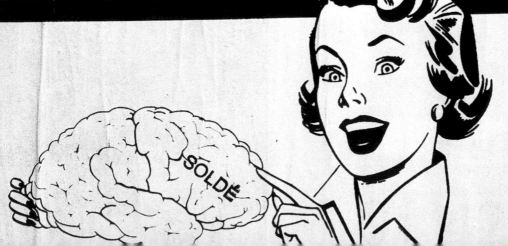

DANS 100 ANS, VOUS SEREZ TOUS MORTS

ENVOLEZ VOUS

ELGER

TOUS LES JOURS
JE LAVE MON CERVEAU
AVEC LA TELE

TO
JE L
A

SOLDÉ

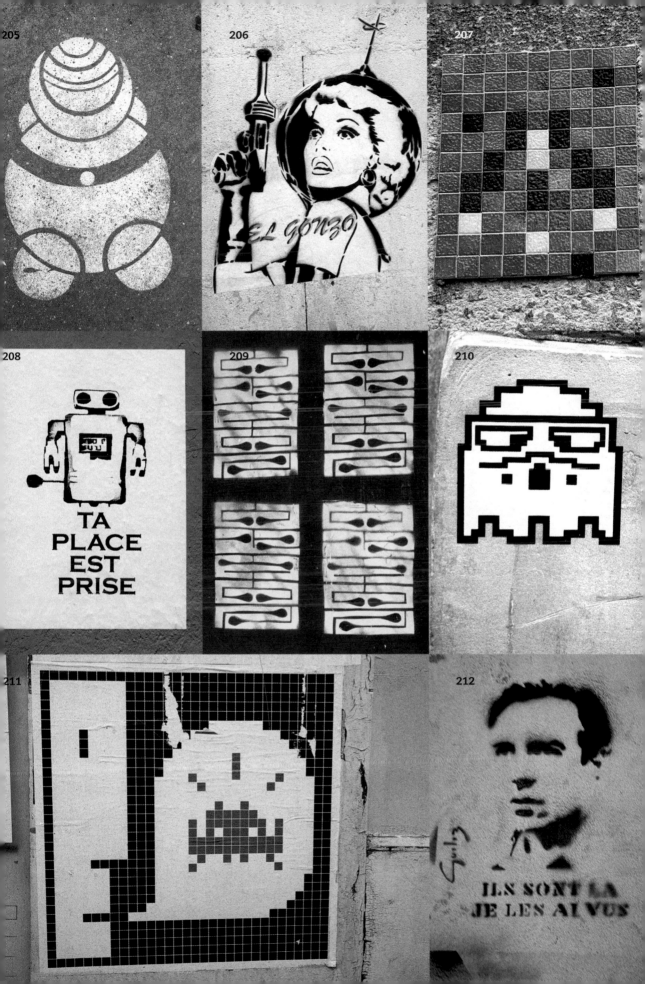

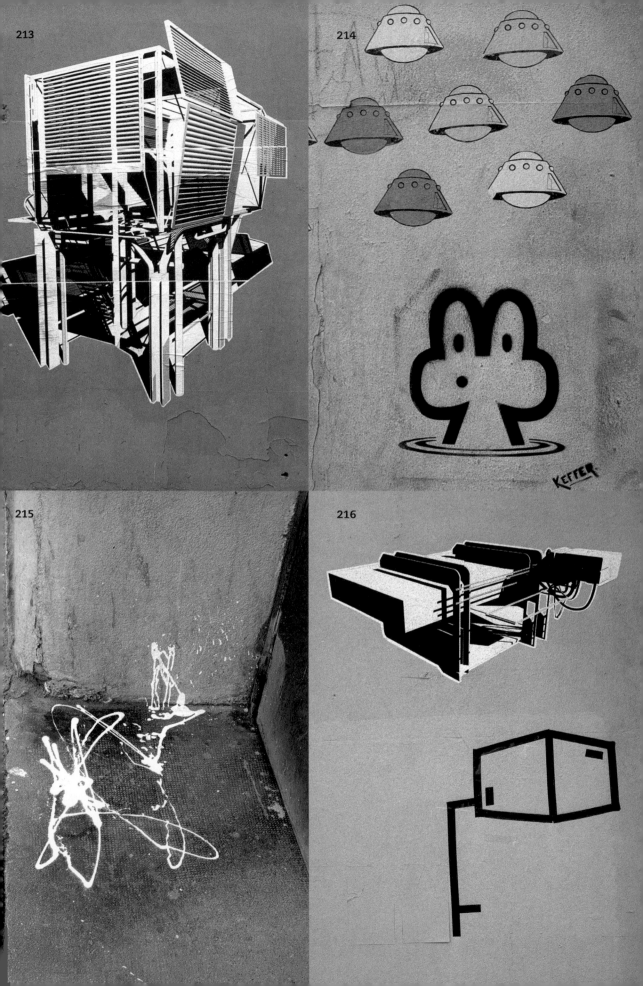

213

214

215

216

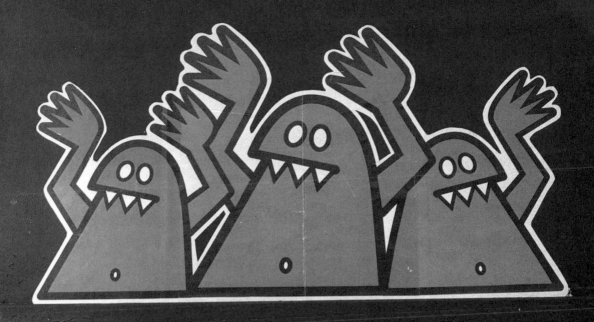

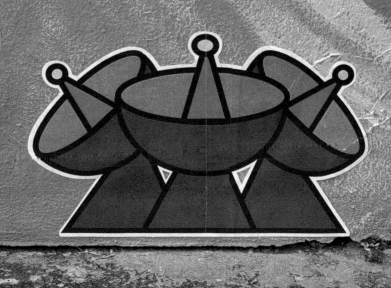

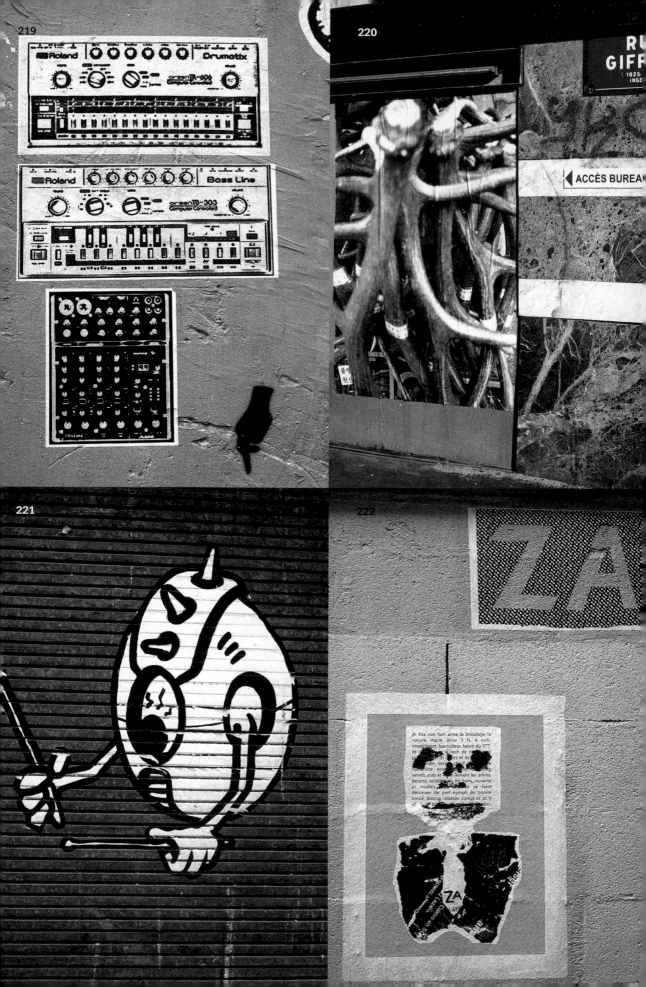

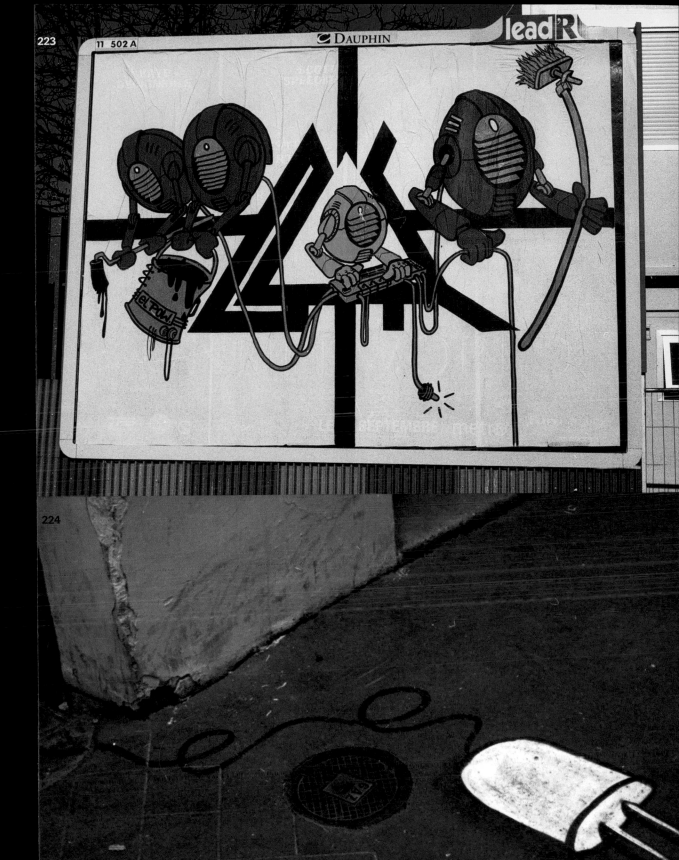

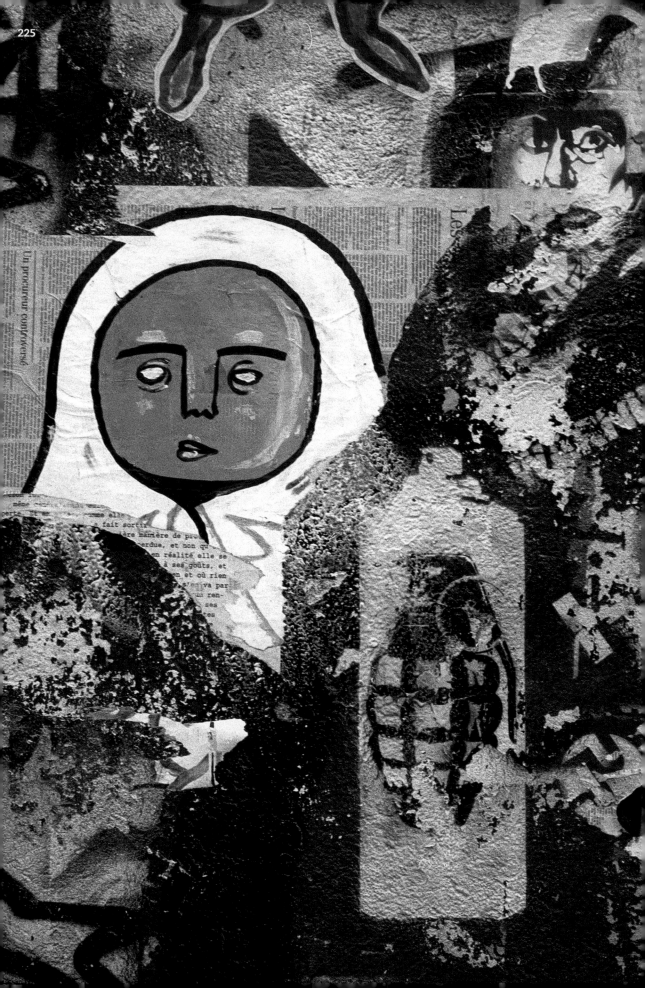

227

ZAPATA

228

229

230

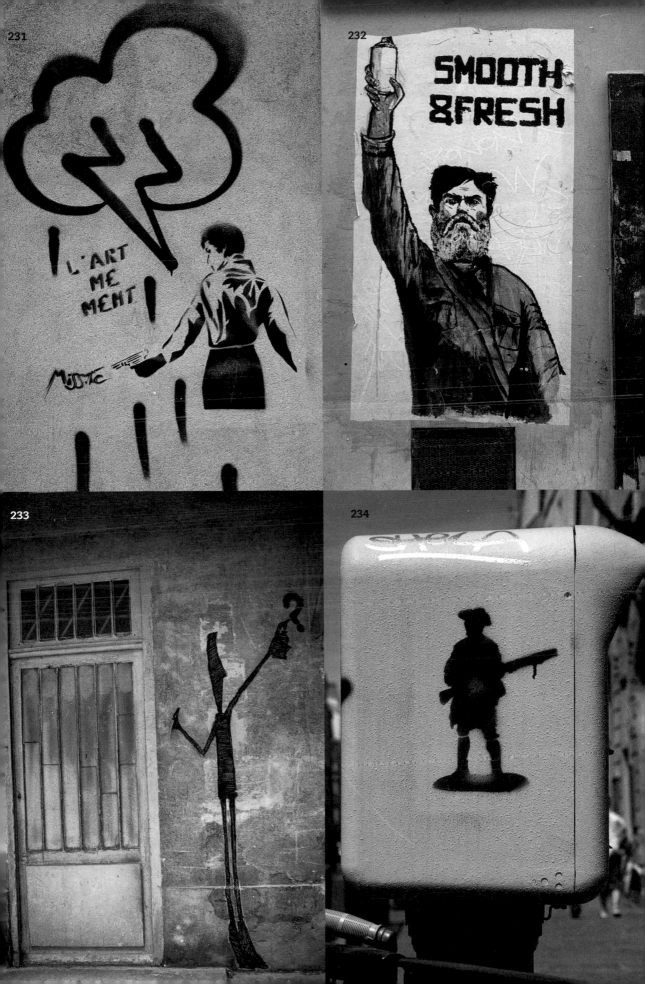

231

232

233

234

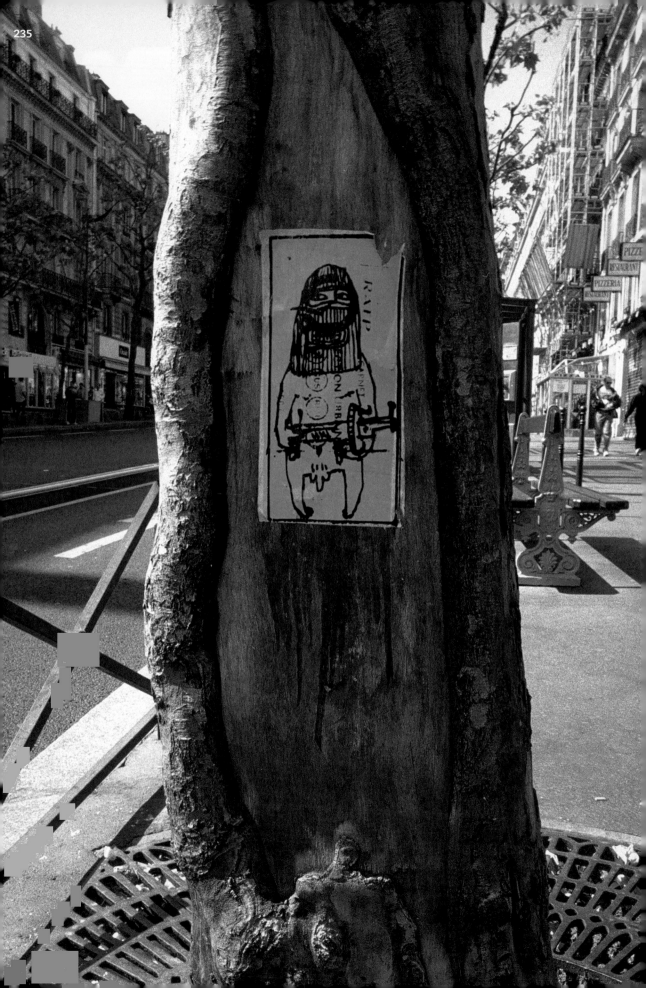

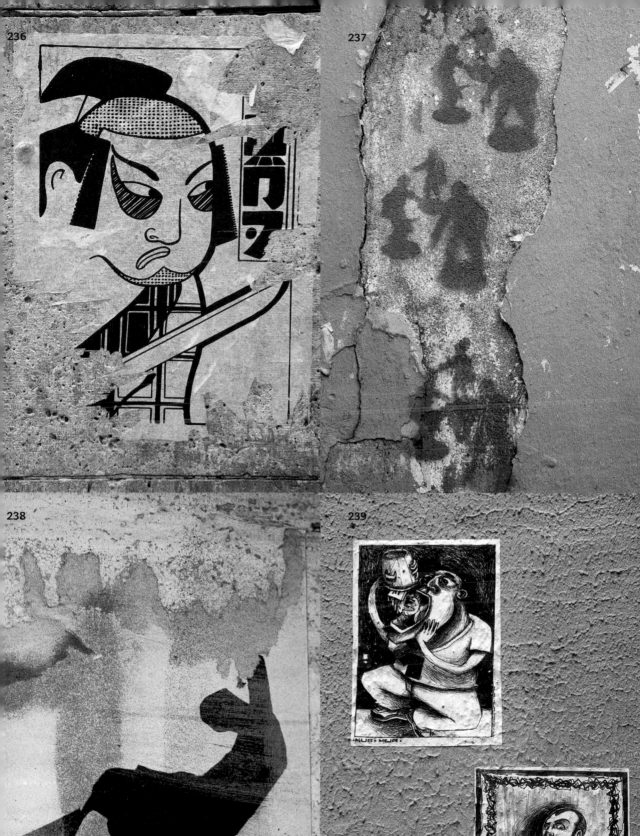

236

237

238

239

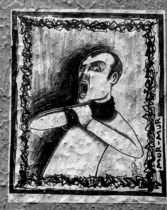

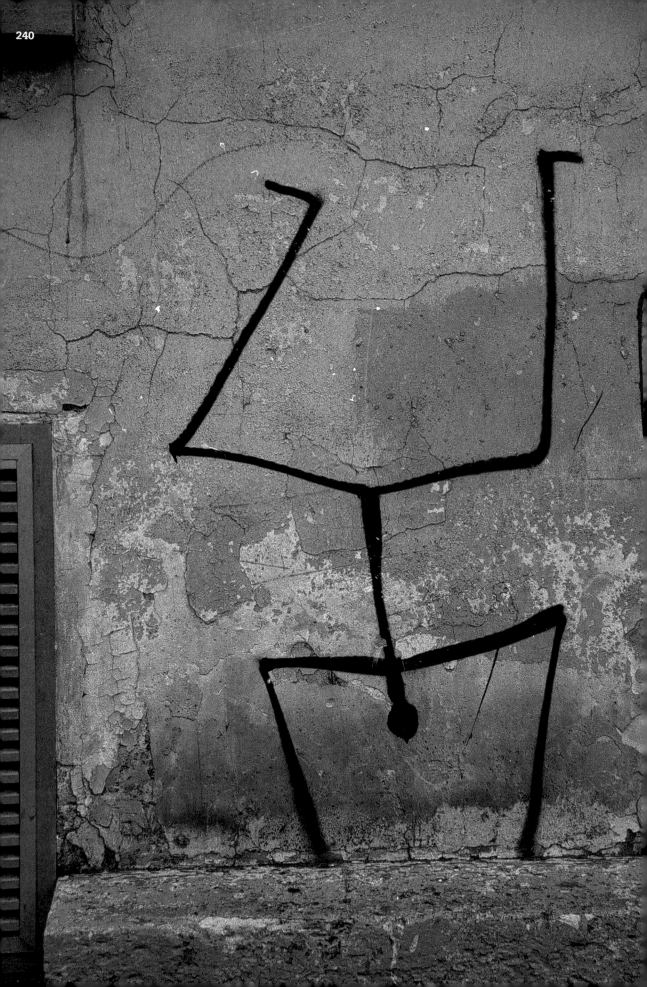

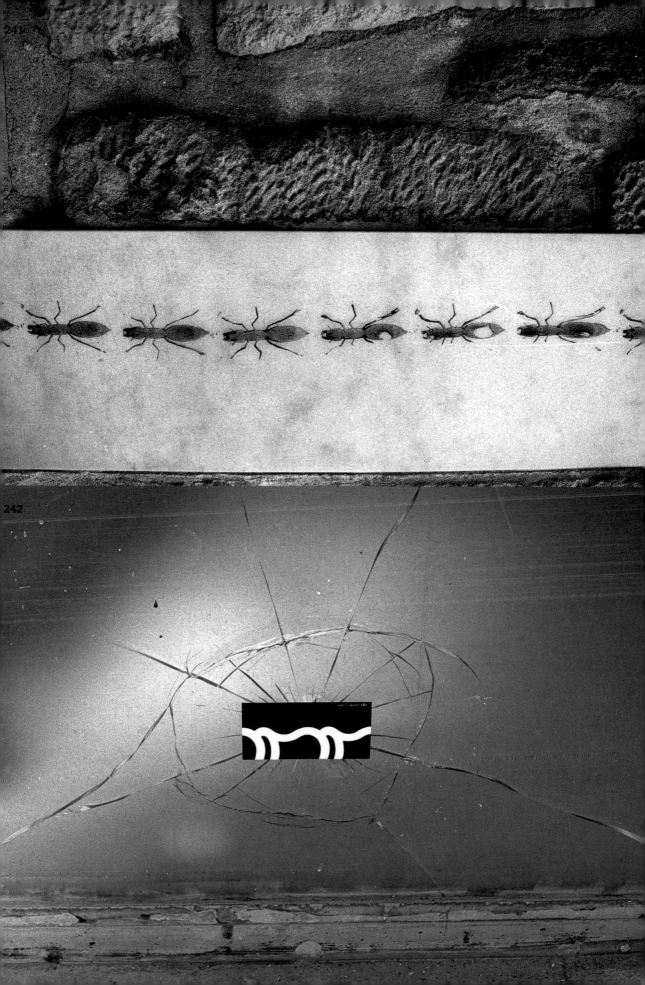

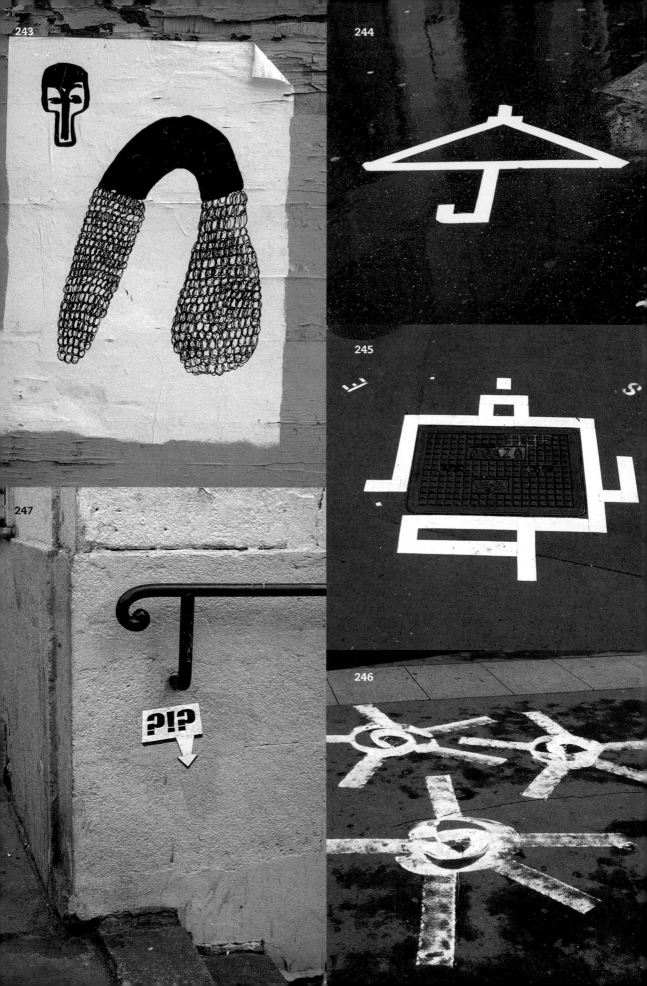

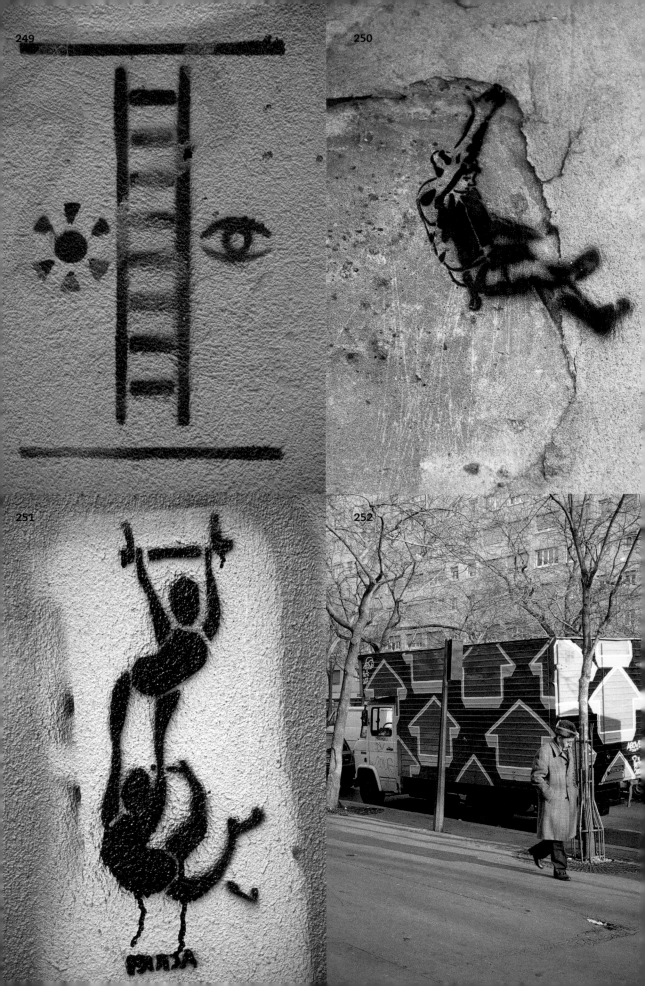

249

250

251

252

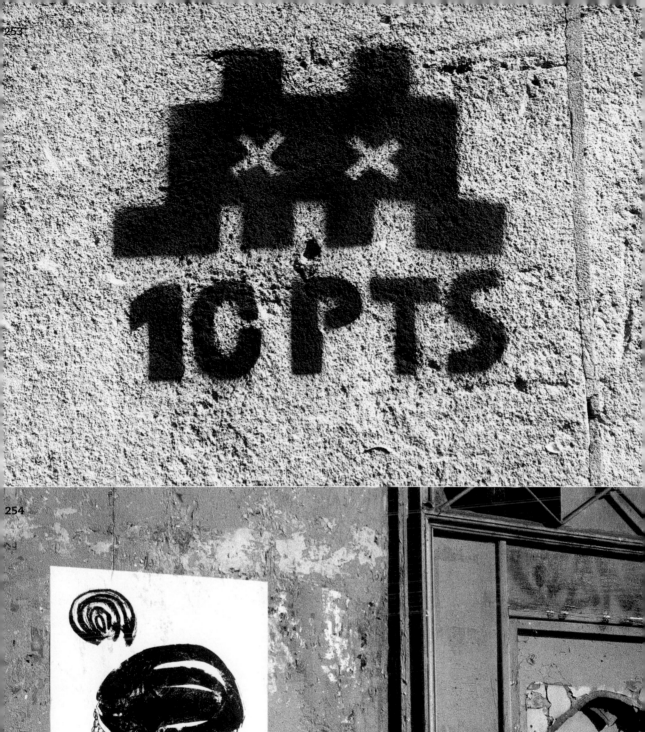

253

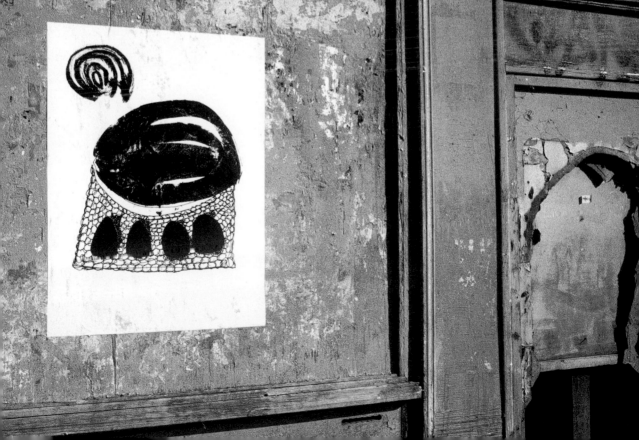

254

255

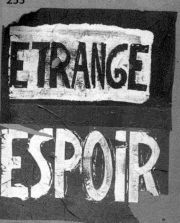

ETRANGE ESPOIR

256

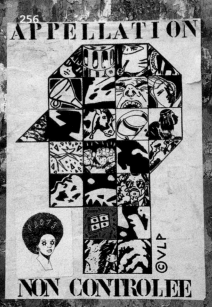

APPELLATION

NON CONTROLEE

©VLP

257

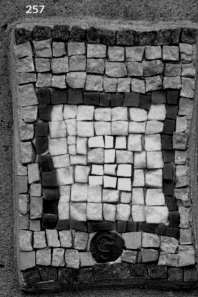

258

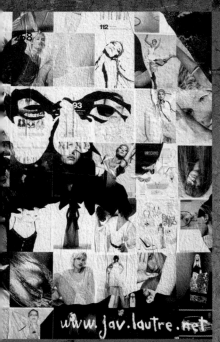

112

www.jav.lautre.net

260

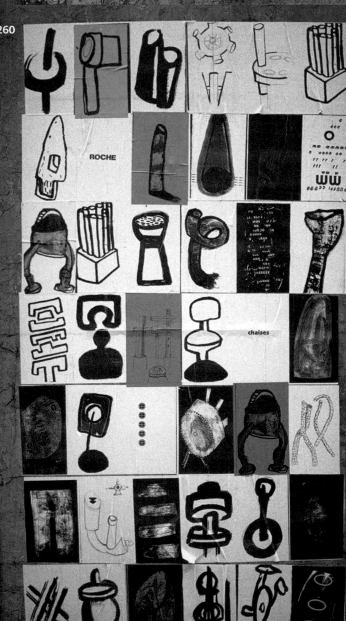

ROCHE

chaises

259

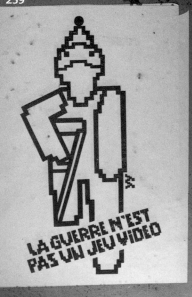

LA GUERRE N'EST PAS UN JEU VIDEO

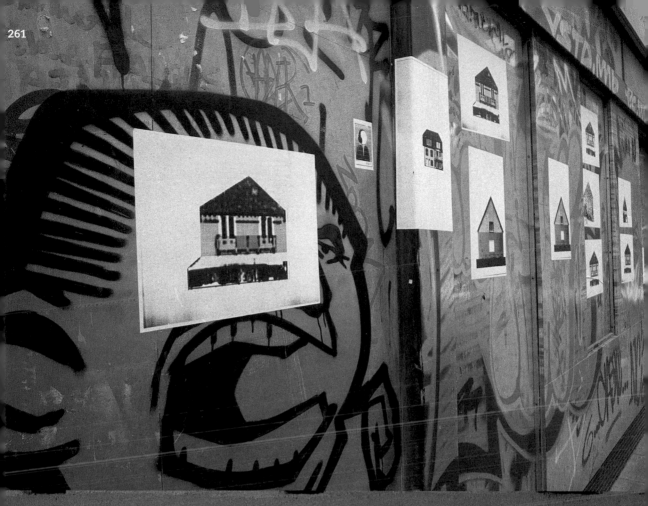

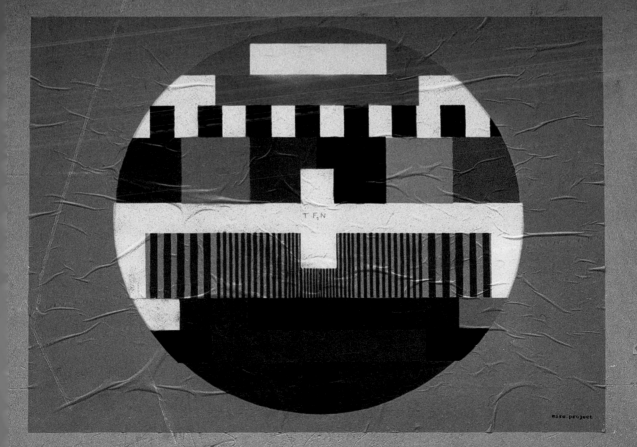

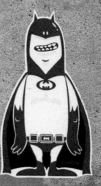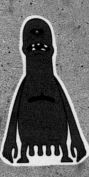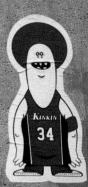

[INSURRECTION]

◀ ACCÈS BUREAUX ⬡ CBC

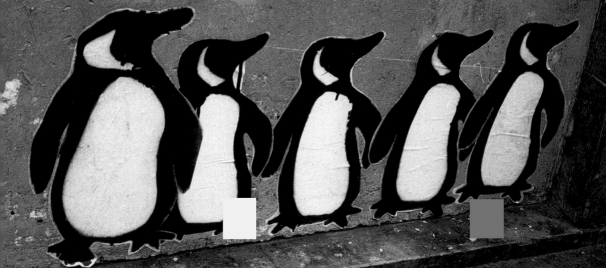

[DESOBEIR]

ARE YOU DUBIOUS?

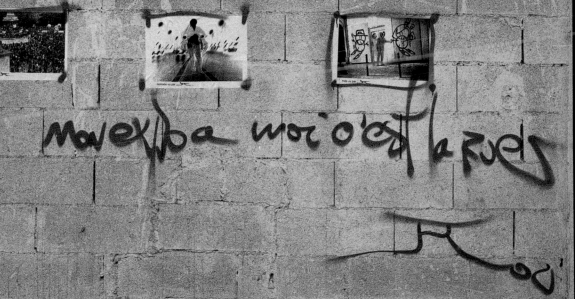

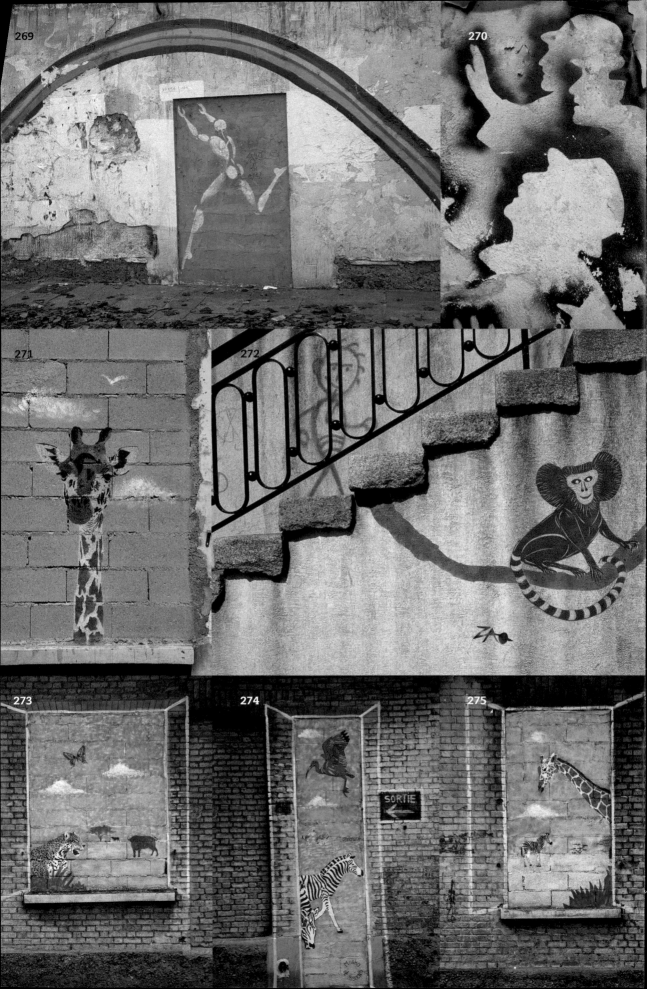

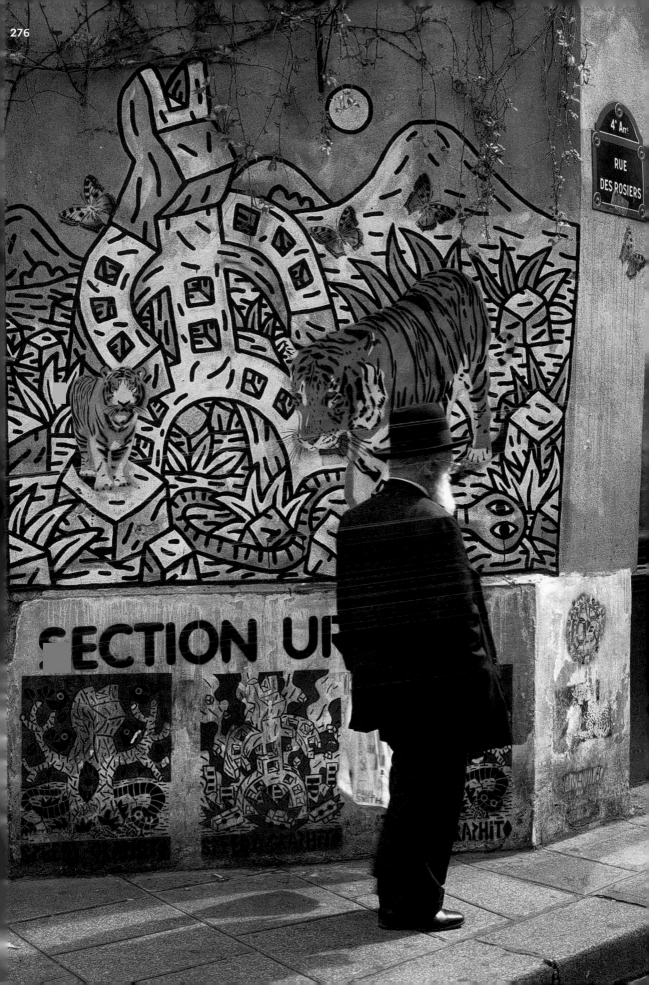

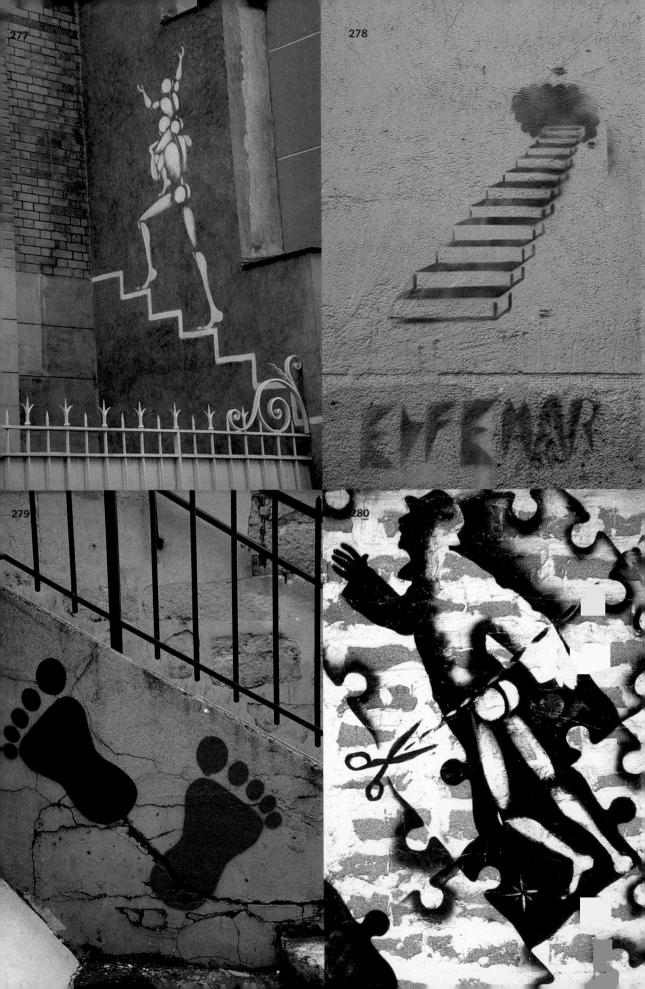

277

278

279

280

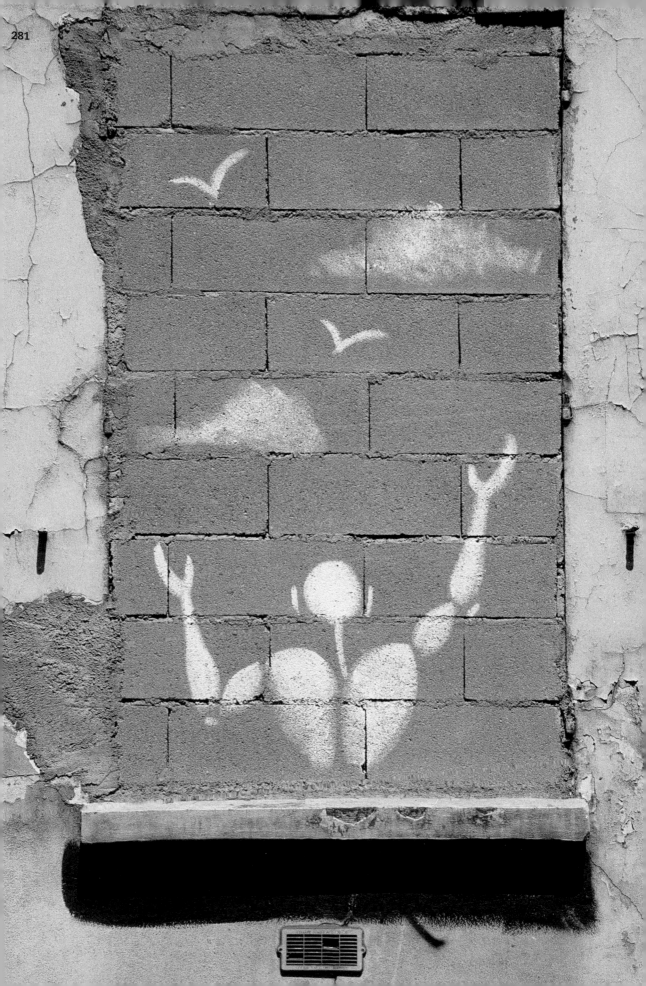

Captions

- - - -
1 / **AEM**, *Black Heads*, sticker, The Marais, 3rd–4th arrondissements (arr.), 2005.

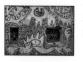

- - - -
2 / **CHANOIR (BLACKCAT)**, *Cats at the Windows*, spray painting in a vacant lot, Jaurès, 19th arr., 1997.

- - - -
3 / **JACE**, *Gouzou-gore*, spray paint and color print pasted on wall, rue Vieille-du-Temple, 3rd–4th arr., 2006.

4 / **CRUNCH**, *Out of the Hole*, poster, The Marais, 3rd–4th arr., 2004.

5 / **EROSIE** and **ÉTRON (TURD)**, *Pirate and Glued Poop*, silk screen and stamp, for an exhibition on rue Tiquetonne, 2nd arr., 2003.

6 / **VLP**, *Zuman*, photocopy pasted on wall, The Marais, 3rd–4th arr., 2006.

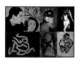

- - - -
7 / **ANONYMOUS**, *Pink and Blue Portraits*, posters, rue Oberkampf, 11th arr., 2003.

8 / **SIMON BERNHEIM**, *Calligraphy on the Sidewalk*, painting, The Marais, 3rd–4th arr., 2001.

9 / **EAST ERIC**, *Masked Advertisement*, defaced advertisement in the Bastille metro station, 4th–12th arr., 2003.

10 / **MEZZO FORTE**, *Human?*, poster, rue Trousseau, 11th arr., 2007.

11 / **ANONYMOUS**, *Woman with Black Gloves*, stencil, The Marais, 3rd–4th arr., 1997.

12 / **DAVID GOUNY**, *Pinup in a Bathing Suit*, spray-painted poster, passage des Taillandiers, 11th arr., 2006.

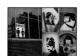

- - - -
13 / **GLF**, *Men and Women*, photocopies pasted on window, Forum des Halles, 1st arr., 2006.

14 / **ANONYMOUS**, *Japanese Woman*, stencil, Belleville, 19th–20th arr., 2004.

15 / **HNT**, *Man with a Tie*, painting, l'Opéra, 2nd–9th arr., 2000.

16 / **FREMANTLE**, *Hmong Woman*, stencil, passage des Taillandiers, 11th arr., 2005.

17 / **ANONYMOUS**, *An Apparition*, spray-painted poster, Belleville, 19th–20th arr., 2006.

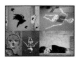

- - - -
18 / **ANTOINE GAMARD**, *Crows' Flight*, stencils, 1st arr., 2000.

19 / **ANONYMOUS**, *Death's Head*, stone carving, rue des Panoyaux, 20th arr., 2003.

20 / **ANONYMOUS**, *Anubis*, stencil, rue Notre-Dame-des-Champs, 6th arr., 2003.

21 / **ANONYMOUS**, *The Skeleton*, stencil, Saint-Germain-des-Prés, 6th arr., 2003.

22 / **MISS.TIC**, Self-Portrait, stencil, rue Debelleyme, 3rd arr., 1997.

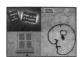

- - - -
23 / **ANONYMOUS**, *Letter Shitter. Wasting Your Life to Make a Living*, stencil, Saint-Germain-des-Prés, 6th arr., 2001.

24 / **ANONYMOUS**, *A Single Dream*, red chalk, rue Legouvé, 10th arr., 2003.

25 / **ANONYMOUS**, *Tear in Your Eye*, spray painting, Belleville, 19th–20th arr., 1996.

Translation of graffiti text:

- - - -

6 / **VLP:** I resist

26 / **MISS.TIC:** Learned woman
I revitalize the language.

37 / **PAELLA:** [top] Fuck AIDS.
[shirt] Touch my rubber.
[bottom] Cover up for love.

50 / **ANONYMOUS:** Even though you don't
look upon it
favorably
the landscape is
not ugly
It may be
your way of looking
that is bad

77 / **ANONYMOUS:** I want to leave. I must leave
right away. It's too hot in this
fucking city.
I want to go to Africa, and stand
under the snow.
I have to leave because I'm going
to die.
Anyway, no one cares about
anyone.
Men need women
and women need men.
But there is no love.

83 / **SCANDAL:** I love my neighborhood
I paste!

88 / **CHANOIR:** The black cat

112 / **ANONYMOUS:** On a fence
in a poor neighborhood
poorly pasted posters
Grand Spring Ball
illuminate
the shadow of an emaciated tree
and that of a lamppost waiting to
be lit

Before these classifieds placed
by life
a passerby stopped
enchanted

He's a picture peddler
and even, unknown to himself
a traveling musician
who plays his own take
on the Rite of Spring
especially in winter
and it's always the same tune
intense and overwhelming
to temper space
to space out time
Always a portrait of the things
and people
that touched him

- - - -translation continued on page 125- - - -

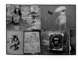

26 / MISS.TIC, *Learned Woman*, stencil, 19th arr., 1997.

27 / LASZLO, *Tiger-Woman*, stencil, Bastille, 4th–12th arr., 2004.

28 / 4 M, *Woman in the Waves*, poster, République, 3rd–10th arr., 2003.

29 / ANONYMOUS, *The Masked Bird*, silk-screen cutout, The Marais, 3rd–4th arr., 2005.

30 / ASBESTOS, *Unseen*, decal on tiling, rue Vieille-du-Temple, 3rd–4th arr., 2005.

- - - -

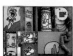

31 / LUCIE, *The Mother-Goddess*, painting, Saint-Germain-des-Prés, 6th arr., 1997.

- - - -

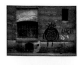

32 / ANONYMOUS, *Woman Torn Apart*, poster, Belleville, 19th–20th arr., 2003.

33 / PAELLA, *Safety Gear and Given That*, slogan posters, The Marais, 3rd–4th arr., 1999.

34 / VOODOÖO, *Love on Earth*, paint on poster, Ménilmontant, 20th arr., 2002.

35 / ANONYMOUS, *Zoophilia*, photocopy cutouts pasted on wall, The Marais, 3rd–4th arr., 2006.

36 / ANONYMOUS, *Two Sheep*, photocopy cutouts pasted on wall, The Marais, 3rd–4th arr., 2006.

37 / PAELLA, *Cover Up for Love*, silk-screen poster, The Marais, 3rd–4th arr., 2004.

38 / M2, *My Little Star*, sticker, The Marais, 3rd–4th arr., 2004.

39 / ANONYMOUS, *Dog*, painting cutout pasted on wall, passage Saint Antoine, 11th arr., 2005.

- - - -

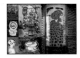

40 / ÉTRON, *Stenciled Poop*, stencil, Belleville, 19th–20th arr., 2005.

41 / ANONYMOUS, *Little Bear*, collage, rue Saint-Antoine, 4th arr., 2007.

42 / VEENOM, *Boy with Birds*, poster, canal Saint-Martin, 10th arr., 2003.

43 / DAVE KINSEY, *Portrait*, poster, canal Saint-Martin, 10th arr., 2004.

44 / BURGLAR, *Burglar with Piece of Paper*, poster, 6th arr., 2003.

45 / OPT, *The Scream*, poster, The Marais, 3rd–4th arr., 2003.

- - - -

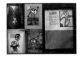

46 / JACE, *Gouzou Pulls the Zipper*, painting pasted on wall, rue Sainte-Croix-de-la-Bretonnerie, 4th arr., 2006.

47 / ANONYMOUS, *One, Two, Three, Sunshine!*, hand-drawn sticker, rue Etienne Marcel, 1st–2nd arr., 2004.

48 / ANONYMOUS, *Figure with Balloon*, collage, rue Saint-Antoine, 4th arr., 2003.

49 / FAFI, *The Green Girl with Big Ears*, painting, rue Delambre, 14th arr., 1998.

50 / ANONYMOUS, *Graffiti-Poetry*, poster, 13th arr., 2001.

- - - -

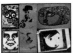

51 / ZBS, *Abstrakt, Visual, Past, Present, Futur, Live and Die*, poster, rue Trousseau, 11th arr., 2007.

52 / PIXAL PARASIT (PP), *Hitchcock*, stencil, rue Sainte-Croix-de-la-Bretonnerie, 4th arr., 2005.

53 / SHEPARD FAIREY, *Obey Giant*, sticker, rue Saint-Paul, 4th arr., 2003.

54 / HAO, *Snarl*, stencil, The Marais, 3rd–4th arr., 2001.

55 / NEKOTWO, *Head*, painting collage, passage des Taillandiers, 11th arr., 2007.

56 / MAMACITA, *Surprise!*, poster, Les Halles, 1st arr., 2004.

- - - -

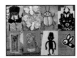

57 / ANONYMOUS, *Work-Unemployment*, silk-screen poster, 6th arr., 2006.

58 / GILBERT/MAZOUT (GILBERT/OIL FUEL), *Piece of the Puzzle*, stencil, rue Oberkampf, 11th arr., 2003.

59 / LE PIGEON (THE PIGEON), *Paris Pigeon*, sticker, 4th arr., 2003.

60 / MIGUEL DONVEZ, *Political Clown*, poster, The Marais, 3rd–4th arr., 2006.

61 / YZ/OPEN YOUR EYES, *White Face*, stencil, boulevard Edgar Quinet, 14th arr., 2003.

- - - -

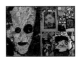

62 / ANONYMOUS, *Woman with a Wallpaper Coat* (detail), collage, rue Saint-Martin, 4th arr., 2004.

63 / ANONYMOUS, *Bugs Over Paris*, collage on a map of Paris, 4th arr., 2004.

64 / YANN PAOLOZZI, *Hands Up*, poster, The Marais, 3rd–4th arr., 1999.

65 / NEKOTWO, *The Old Lady*, painting pasted on wall, Belleville, 19th–20th arr., 2005.

66 / KOLEO, *Bug on the Door*, collage, 5th arr., 2004.

67 / ANONYMOUS, *African Head* (detail), spray-painted mural, passage Boudin, 20th arr., 1998.

68 / ANONYMOUS, *Black Man*, poster, The Marais, 3rd–4th arr., 2005.

69 / FLY-TOX, *Bee*, collage on wall, rue Pastourelle, 3rd arr., 2004.

- - - -

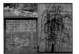

70 / ANONYMOUS, *The Scream*, painting in a wild garden, rue des Haies, 20th arr., 2006.

71 / ANONYMOUS, *Street Portrait*, silk screen, rue Oberkampf, 11th arr., 2005.

72 / JIEM, *Heading the Bill*, paint on posters, passage des Taillandiers, 11th arr., 2005.

73 / ANONYMOUS, *Random Heads*, painted panels, rue Saint-Antoine, 4th arr., 2003.

- - - -

74 / JEROME MESNAGER, *Luncheon on the Grass* (*Le déjeuner sur l'herbe*), painting, Belleville, 19th–20th arr., 1997.

75 / ANONYMOUS, *After Pollock*, thrown paint, passage des Taillandiers, 11th arr., 2007.

- - - -

76 / 36RECYCLAB, *Satellite*, poster, Charonne, 11th arr., 2004.

77 / ANONYMOUS, *Urban Poetry*, poster, Belleville, 19th–20th arr., 2002.

78 / BONOM (GUY), *Reptile Skeleton*, silk-screen cutout, rue de la Roquette, 11th arr., 2005.

79 / MARTIN, *Marine-Landscape*, poster, rue du Faubourg-Saint-Antoine, 11th–12th arr., 2002.

- - - -

80 / ANDRÉ, *Grimacing Mailbox*, painting, The Marais, 3rd–4th arr., 2001.

81 / ANONYMOUS, *Dog Peeing*, poster, place Edmond-Michelet, Beaubourg, 4th arr., 2004.

82 / FETICHE (FETISH), *Cat Head*, photocopy cutout, The Marais, 3rd–4th arr., 2005.

83 / SCANDAL, *I Love My Neighborhood, Call for a Lack of Civic Spirit*, poster, The Marais, 3rd–4th arr., 2003.
84 / MONSIEUR CHAT (MISTER CAT), *Guy*, stencil on a stanchion, Ménilmontant, 20th arr., 2006.
85 / SPACE INVADER, *Space*, mosaic, rue Vieille-du-Temple, 3rd–4th arr., 2001.
86 / STICKOPATHES, *Angus Young*, poster, The Marais, 3rd–4th arr., 2003.

- - - -

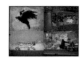

87 / ANTOINE GAMARD, *The Deluge Crow*, stencil, The Marais, 3rd–4th arr., 2001.
88 / CHANOIR, *A Black Cat on a Wall*, painting, Jaurès, 19th arr., 1997.
89 / MONSIEUR CHAT, *With a Nemo Umbrella*, paint and stencil, canal Saint-Martin, 10th arr., 2001.
90 / MISS.TIC and NEMO, *A Little Piece of Umbrella Paradise*, stencil and paint, quai de l'Oise, 19th arr., 1997.

- - - -

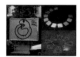

91 / VAST, *Look Where the Look Looks*, defaced billboard, rue du Faubourg-Saint-Antoine, 11th–12th arr., 2002.
92 / ANONYMOUS, *Chromatic Circle*, painting, rue Oberkampf, 11th arr., 2007.
93 / MONSIEUR CHAT, *The Ring*, stencil, canal de la Vilette, 19th arr., 2003.

- - - -

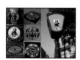

94 / GLF, *Man-Woman*, stencil, République, 3rd–10th arr., 2002.
95 / ANONYMOUS, *Chromatic Circle and Hand on a Manhole Cover*, painting, rue Oberkampf, 11th arr., 2007.
96 / PRUNE, *Even on a Leash*, defaced traffic sign, Square Charles-Victor-Langlois, 4th arr., 2006.
97 / ANONYMOUS, *Gun Shot*, stencil, The Marais, 3rd–4th arr., 1997.
98 / ANONYMOUS, *Woman on a Manhole Cover*, painting, 20th arr., 2007.
99 / ANONYMOUS, *Ying-Yang*, stencil, Belleville, 19th–20th arr., 2005.
100 / LE PIGEON, *Bus Stop*, sticker, Les Halles, 1st arr., 2003.

- - - -

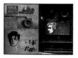

101 / ANONYMOUS, *January 1910 Water Level*, stencil on poster, Saint-Germain-des-Prés, 6th arr., 2006.
102 / ANONYMOUS, *Stencil Boy*, stencil, The Marais, 3rd–4th arr., 1997.
103 / GILBERT/MAZOUT, *Head Without Eyes*, poster, rue Ligner, 20th arr., 2003.

- - - -

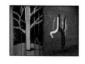

104 / JEROME MESNAGER, *The White Man and the White Tree*, stencil on fence, Belleville, 19th–20th arr., 1997.
105 / LIGNESROUGES (REDLINES), *Red and White Abstraction*, painting, Beaubourg, 3rd–4th arr., 2005.

- - - -

106 / SADHU, *Woman with Child*, stencil pasted on wall, canal Saint-Martin, 10th arr., 2003.
107 / ANONYMOUS, *The Hole and Black Splash*, painting pasted on wall and paint drips, rue de Charonne, 11th arr., 2004.
108 / DIEU (GOD), *I Am the Light in Your Darkness*, poster, rue Vieille-du-Temple, 3rd–4th arr., 2004.

109 / ANONYMOUS, *The Hand of God*, collage, rue des Archives, 3rd–4th arr., 2004.

- - - -

110 / CHANOIR, *Hidden Cat*, painting in a vacant lot, Jaurès, 19th arr., 1997.
111 / JIEM, *Exotic Portrait*, silk screen, passage Saint-Antoine, 11th arr., 2004.
112 / ANONYMOUS, *For Izis*, paper pasted on wall, place d'Italie, 13th arr., 2001.
113 / VLP, *Zuman*, photocopy pasted on wall, The Marais, 3rd–4th arr., 2006.

- - - -

114 / CHANOIR, *In Every Language*, painting in a vacant lot, Jaurès, 19th arr., 1997.
115 / GILBERT/MAZOUT and VEENOM, *Two Dogs*, poster and paint, rue Oberkampf, 11th arr., 2003.

- - - -

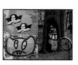

116 / ANONYMOUS, *Angels*, stencils pasted on wall, rue Denoyez, 20th arr., 2004.
117 / CHANOIR, *A Little Green*, poster, Saint-Germain, 6th arr., 2001.
118 / MONSIEUR CHAT, *In the Tree*, painting, quai du Louvre, 1st arr., 2001.

- - - -

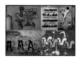

119 / MUSHI, *Pimp Pizza*, painted poster cutout, The Marais, 3rd–4th arr., 2005.
120 / MISS.TIC, *Walk, Run, Fall*, stencil, 19th arr., 1997.
121 / ANONYMOUS, *New Paris Marathon*, poster, 6th arr., 2006.
122 / GIL BENSMANA, IS BACH, and MIGUEL DONVEZ, collage, rue Vieille-du-Temple, 3rd–4th arr., 2006.
123 / GOMES, *Squirrels*, stickers, rue Saint-Martin, 4th arr., 2001.

- - - -

124 / JEAN FAUCHEUR, *To Drink and to Penetrate Jubilantly*, poster mounted by the artist and VAST, place Sans Nom, rue Oberkampf, 11th arr., 2002.

- - - -

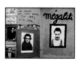

125 / ANONYMOUS, *Well Doctor?* and *Vote for Me*, posters, boulevard Richard Lenoir, 11th arr., 2002.
126 / ANONYMOUS, *Knowledge Is a Weapon My Friend!*, marker on wall, rue Legouvé, 10th arr., 2003.
127 / BLEK, *Blek Was Here*, poster, Les Halles, 1st arr., 2001.
128 / JOHN HAMON, *The Famous Unknown Person on an Electoral Billboard*, posters, boulevard du Montparnasse, 6th–15th arr., 2004.
129 / DE, *Vote for Yourself*, political poster, rue de Poitou, 3rd arr., 2002.
130 / ANONYMOUS, *Megalili*, poster, place d'Italie, 13th arr., 1997.

- - - -

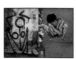

131 / ANONYMOUS, *Black Silhouette*, spray painting, rue Oberkampf, 11th arr., 2001.
132 / GIL BENSMANA, *Naked Man Crouching*, silk screen print pasted on wall, rue Oberkampf, 11th arr., 2003.

- - - -

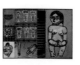

133 / TILT, *Briefs*, stencil, passage Saint-Antoine, 11th arr., 2005.

134 / GIL BENSMANA, *The Art of Immodesty*, collage, boulevard Raspail, 6th–7th arr., 1999.

135 / ANONYMOUS, *Eye See You*, photocopy pasted on wall, The Marais, 3rd–4th arr., 2006.

136 / GIL BENSMANA, *The Art of Immodesty*, collage, boulevard Raspail, 6th–7th arr., 1999.

137 / DAVID GOUNY, *Fat Pinup*, painted poster, Bastille, 4th–12th arr., 2006.

138 / GIL BENSMANA and SPACE INVADER, *Body Fragments*, collages and mosaic, 20th arr., 2001.

139 / NEKOTWO, *Naked*, paint collage, passage Thiéré, 11th arr., 2007.

- - - -

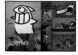

140 / PEZ, *Giant PEZ*, poster, canal Saint-Martin, 10th arr., 2003.

141 / JEY, *Like a Stamp*, collage, rue Oberkampf, 11th arr., 2003.

142 / CRUNCH, *Paste a Portrait, 1, 2, 3!*, collage cutout, The Marais, 3rd–4th arr., 2004.

143 / DINO, *Dino and Mushroom*, painted poster, place de la Réunion, 20th arr., 2003.

144 / LUDWIGRAPHIK, *Indian Sun*, poster, rue Oberkampf, 11th arr., 2005

145 / ALËXONE, *Wall-Hopper*, painted cutout pasted on wall, rue de Lancry, 10th arr., 2003.

- - - -

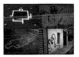

146 / L'ATLAS (THE ATLAS), *Compass*, defaced manhole cover, collage and stencil, 20th arr., 2002.

147 / ANONYMOUS, *Diving Suit*, painting, The Marais, 3rd–4th arr., 2002.

148 / ANDRÉ, *The Running Man*, spray painting, The Marais, 3rd–4th arr., 2002.

149 / ANONYMOUS, *The Walking Potato*, unfinished wall painting, The Marais, 3rd–4th arr., 1997.

- - - -

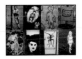

150 / JEF AEROSOL, *Bruce Springsteen*, stencil pasted on wall, The Marais, 3rd–4th arr., 2006.

151 / FREMANTLE, *The Scream*, stencil, rue Léon Frot, 11th arr., 2006.

152 / ANONYMOUS, *Portrait of Nietzsche*, poster assemblage, canal Saint-Martin, 10th arr., 2003.

153 / ANONYMOUS, *Portrait of Charlie Chaplin*, poster, 12th arr., 2001.

154 / CHANOIR, *Anthropomorphic Cat*, painting, Jaurès, 19th arr., 1997.

155 / GILBERT/MAZOUT, *Animal Head*, painting on electoral billboard, The Marais, 3rd–4th arr., 2005.

156 / INFLUENZA, *Moskito*, painting, The Marais, 3rd–4th arr., 2003.

157 / GILBERT/MAZOUT, *Silhouette*, poster on shop window, rue des Archives, 3rd–4th arr., 2003.

- - - -

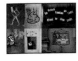

158 / ANONYMOUS, *Figure with a Portfolio*, stencil, École des Beaux-Arts, 6th arr., 2000.

159 / ÉTRON, *Power Poop*, poster, rue Beaurepaire, 10th arr., 2003.

160 / ANDRÉ, *Single Head*, painting, rue Saint-André-des-Arts, 6th arr., 2003.

161 / OPT, *Paint Can*, sticker, The Marais, 3rd–4th arr., 2003.

162 / ANONYMOUS, *Art's Greatest Enemy Is Good Taste*, stencil, Saint-Germain-des-Prés, 6th arr., 2001.

163 / MONSIEUR CHAT, *Framed*, painting, rue des Beaux-Arts, 6th arr., 2001.

- - - -

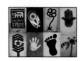

164 / SPEEDY GRAPHITO, *Cat and Snake*, painting, Mouffetard, 5th arr., 2005.

165 / ANONYMOUS, *Creature*, sticker, rue du Faubourg-Saint-Antoine, 11th–12th arr., 2003.

166 / SIMON BERNHEIM, *CRUST*, silk screen, The Marais, 3rd–4th arr., 2002.

167 / ANONYMOUS, *The White Hand*, stencil, 20th arr., 2007.

168 / FLOWER GUY, *Flower*, poster, boulevard de Sébastopol, 1st–4th arr., 2007.

169 / ANONYMOUS, *Hand of Fatima*, stencil, rue de Belleville, 19th arr., 2000.

170 / ANONYMOUS, *Black Footprint*, stencil, Ménilmontant, 20th arr., 2000.

171 / ANONYMOUS, *Handprint with Flower*, spray painting, Ménilmontant, 20th arr.,1997.

- - - -

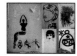

172 / FKDL, *Silhouettes*, collages, passage des Taillandiers, 11th arr., 2007.

173 / GILBERT/MAZOUT, *Head without Eyes*, poster, rue des Archives, 3rd–4th arr., 2003.

174 / ANONYMOUS, *Punk*, stencil, Belleville, 19th–20th arr., 1997.

175 / LASZLO, *Tomboy*, stencil, Bastille, 4th–12th arr., 2004.

176 / JIEM, *Torn Portrait*, passage du Commerce-Saint-André, 6th arr., 2004

- - - -

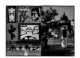

177 / TI.TIKI, *Tiki*, sticker, canal Saint-Martin, 10th arr., 2003.

178 / SIMON BERNHEIM, *Calligraphy*, silk-screen print pasted on wall, boulevard Saint-Germain, 5th–6th arr., 1999.

179 / JONZO, *Frankenstein*, poster, Saint-Germain-des-Prés, 6th arr., 2002.

180 / SIMON BERNHEIM, *Calligraphy*, silk screen, avenue Daumesnil, 12th arr., 2000.

181 / GOLGOTH, *Flying Saucers*, poster, rue Oberkampf, 11th arr., 2003.

182 / AKIM, *Writing*, painting, quai de Valmy, 10th arr., 2004.

183 / MR TACHE (MR. STAIN), *Stain*, poster on an advertising column, boulevard de Ménilmontant, 11th–20th arr., 2001.

- - - -

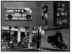

184 / G, *Bus*, sticker, rue Beaurepaire, 10th arr., 2003.

185 / G, *Gas Station*, poster, boulevard de Ménilmontant, 11th–20th arr., 2007.

186 / ANONYMOUS, *The Photo-Camera-Man*, silk screen, The Marais, 3rd–4th arr., 2005.

187 / ANONYMOUS, *My Freedom Hurts*, stencil, rue Saint-Antoine, 4th arr., 2002.

188 / LIFE REMOTE CONTROL, *The Cameraman*, stencil, The Marais, 3rd–4th arr., 2006.

- - - -

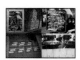

189 / ANONYMOUS, *Cultural Democracy*, silk screen, rue Oberkampf, 11th arr., 2005.

190 / IS BACH, *Housing Project*, poster, boulevard de Ménilmontant, 11th–20th arr., 2006.

191 / ANONYMOUS, *Two-Way Traffic*, stencil, The Marais, 3rd–4th arr., 2004.

192 / G and MONSIEUR (MISTER), *Accumulation of Cars*, stickers, rue Beaurepaire, 10th arr., 2003.

193 / G, *Front-Back*, poster, Saint-Germain-des-Prés, 6th arr., 2003.

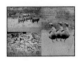

– – – –
194 / **ANONYMOUS**, *The Cows*, Les folies fermières
(The Farming Follies) series, colored photocopies, rue
des Panoyaux, 20th arr., 2002.
195 / **ANONYMOUS**, *New Mural Paintings*, stencils, rue
des Vignoles, 20th arr., 2000.
196 / **ANONYMOUS**, *The Geese*, Les folies fermières series,
colored photocopies, rue des Panoyaux, 20th arr., 2002.

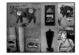

– – – –
197 / **ANONYMOUS**, *Tiled Cow*, mosaic, Village Saint-
Paul, 4th arr., 2006.
198 / **GILBERT/MAZOUT**, *Steak*, painted cutout, canal
Saint-Martin, 10th arr., 2003.
199 / **MILKLADY**, *Milk Bottle*, stencil on two tiles,
passage Thiéré, 11th arr., 2004.
200 / **VEENOM**, *Laughing Cow*, poster, canal Saint-
Martin, 10th arr., 2003.
201 / **ANONYMOUS**, *Kebab*, stencil, rue Quincampoix,
3rd–4th arr., 2001.
202 / **GILBERT/MAZOUT**, *Portrait and Drips* (detail),
posters, rue des Archives, 3rd–4th arr., 2003.

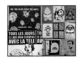

– – – –
203 / **ELGER**, *In One Hundred Years You'll All Be Dead*,
defaced billboard, place Sans-Nom, rue Oberkampf,
11th arr., 2003.
204 / **ANONYMOUS**, *Every Day, I Wash My Brain with
Television*, poster, République, 3rd–10th arr., 2003.
205 / **ANONYMOUS**, *Blue Guy*, stencil, quai de
Jemmapes, 10th arr., 2004.
206 / **LASZLO**, *Super Heroine*, stencil cutout pasted
on wall, rue de Charonne, 11th arr., 2004.
207 / **ANONYMOUS**, *Space Ship,* mosaic, The Marais,
3rd–4th arr., 2002.
208 / **ANONYMOUS**, *Robot*, poster, rue Notre-Dame-
des-Champs, 6th arr., 2005.
209 / **ANONYMOUS**, *Blue Abstractions* (detail), stencil,
The Marais, 3rd–4th arr., 2004.
210 / **ANONYMOUS**, *Invader*, plastic-coated sticker,
The Marais, 3rd–4th arr., 2006.
211 / **SPACE INVADER**, *Did You Say Space?*, silk screen,
rue Notre-Dame-des-Champs, 6th arr., 2001.
212 / **NELUNDETH**, *David Vincent*, stencil, passage
Sainte-Avoie, 3rd arr., 1999.

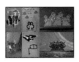

– – – –
213 / **36RECYCLAB**, *Machine*, assembled posters pasted
on wall, passage Saint-Antoine, 11th arr., 2004.
214 / **KEFFER**, *Tet' Nouye (Noodle Head)* and *Flying
Saucer*, silk screens pasted on wall and stencil,
The Marais, 3rd–4th arr., 2005.
215 / **ANONYMOUS**, *Street Dripping*, paint drips,
rue de Charonne, 11th arr., 2004.
216 / **36RECYCLAB**, *Architectural Form*, poster pasted
on wall, 11th arr., 2005.
217 / **ANONYMOUS**, *Orange Monsters*, silk-screen
cutout, quai de Valmy, 10th arr., 2004.
218 / **ANONYMOUS**, *Satellite Dish Parables*, silk-screen
cutouts pasted on wall, quai de Valmy, 10th arr., 2004.

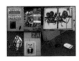

– – – –
219 / **ANONYMOUS**, *Stereo and Little Black Hand*,
collages, rue des Taillandiers, 11th arr., 2007.
220 / **ANTONIO GALLEGO**, *Wood*, silk screen pasted
on wall, rue Giffard, 13th arr., 2005.

221 / **PABLOW**, *Robot*, painting collage on shutters,
Belleville, 19th–20th arr., 2005.
222 / **ZA**, *Classifieds*, silk screen poster, rue
Oberkampf, 11th arr., 2005.
223 / **L'ATLAS** and **PABLOW**, *Tagging Robots and
Compass*, defaced billboard, place de la Nation,
11th–12th arr., 2005.
224 / **THE PLUG**, *The Plug*, painting on pavement,
passage Thiéré, 11th arr., 2006.

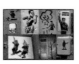

– – – –
225 / **NEKOTWO**, *Head and Grenade*, painted poster
and stencil, Belleville, 19th–20th arr., 2005.
226 / **ELGER**, *Danger: Explosive*, defaced billboard,
place Sans-Nom, rue Oberkampf, 11th arr., 2003.

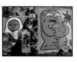

– – – –
227 / **ZAVAPA**, *Spray Paint Revolution*, stencil, rue de
Belleville, 19th–20th arr., 1999.
228 / **IS BACH**, *Do You Want to Fight?*, stencil, rue
Jouye-Rouve, 20th arr., 2006.
229 / **FLYING FORTRESS**, *Head with Helmet*, poster,
location unknown, 2003.
230 / **ANONYMOUS**, *Indian Games*, photocopy, rue
Godefroy-Cavaignac, 11th arr., 2006.
231 / **ZEVS** and **MISS.TIC**, *Art Lies to Me*, spray paint
and stencil, rue Debelleyme, 3rd arr., 2000.
232 / **ANONYMOUS**, *Smooth & Fresh*, poster, rue de
Poitou, 3rd arr., 2005.
233 / **ANONYMOUS**, *Paint on the Walls?*, paper pasted
on wall, rue des Francs-Bourgeois, 3rd–4th arr., 1999.
234 / **THE ART OF URBAN WARFARE/INFLUENZA**, *Green
Soldier*, stencil, The Marais, 3rd–4th arr., 2002.

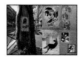

– – – –
235 / **YANN PAOLOZZI**, *To Arms*, poster, boulevard
Saint-Michel, 3rd–4th arr., 1999.
236 / **ANONYMOUS**, *Samurai*, silk screen, rue
Bonaparte, 6th arr., 2000.
237 / **THE ART OF URBAN WARFARE/
INFLUENZA**, *Urban Warfare*, stencil, rue de la
Roquette, 11th arr., 2003.
238 / **ANONYMOUS**, *The Fall*, poster, rue Sainte-Croix-
de-la-Bretonnerie, 4th arr., 2003.
239 / **MUR-MUR**, *Swallow. Choke*, photocopied posters,
rue Saint-André-des-Arts, 6th arr., 2001.

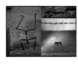

– – – –
240 / **ANONYMOUS**, *Upside-Down Spider-Man*, spray
paint, The Marais, 3rd–4th arr., 1997.
241 / **ANONYMOUS**, *Ants*, stencils on posters,
Belleville, 19th–20th arr., 2001.
242 / **KAMI**, *Like a Skate Line*, sticker on a broken
window, Les Halles, 1st arr., 2003.

– – – –
243 / **JOSÉ MARIA GONZALEZ**, *Enigma*, poster,
The Marais, 3rd–4th arr., 2005.
244 / **PARAPLUIE**, *Underwater Umbrella*, surgical tape
on pavement, The Marais, 3rd–4th arr., 2001.
245 / **L'ATLAS**, *Compass*, defaced manhole cover,
collage and stencil, 20th arr., 2002.
246 / **ANONYMOUS**, *Suns*, painting, boulevard du
Montparnasse, 6th–15th arr., 2003.
247 / **ANONYMOUS**, *?!?*, poster, Montorgeuil, 1st–2nd
arr., 2005.

248 / **ELTONO**, *Logotype Stamped Chanoir*, painting, rue Keller, 11th arr., 2003.

- - - -

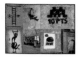

249 / **ANONYMOUS**, *Rebus*, stencil, passage Saint-Antoine, 11th arr., 1998.

250 / **ANONYMOUS**, *Mountain Climber*, stencil, rue Sainte-Croix-de-la-Bretonnerie, 4th arr., 2004.

251 / **ANONYMOUS**, *The Acrobats*, stencil, Ménilmontant, 20th arr., 1997.

252 / **ABOVE**, *Rising Arrows*, painting on truck, boulevard de Ménilmontant, 11th–20th arr., 2002.

253 / **SPACE INVADER**, *Ten Points*, stencil, rue Beaubourg, 3rd–4th arr., 1999.

254 / **JOSÉ MARIA GONZALEZ**, *Rebus*, poster, boulevard Vincent-Auriol, 13th arr., 2005.

- - - -

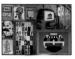

255 / **PATRICK PINON**, *Strange Hope*, poster, The Marais, 3rd–4th arr., 2005.

256 / **VLP**, *Unregistered Designation of Origin*, poster, rue Vieille-du-Temple, 3rd–4th arr., 2001.

257 / **C.J.** (?), *Abstract Mosaic*, Saint-Germain-des-Prés, 6th arr., 2002.

258 / **ANONYMOUS**, *Karl Marx*, poster assemblage, canal Saint-Martin, 10th arr., 2003.

259 / **YVES YACOEL**, *War Is Not a Video Game*, silk screen, The Marais, 3rd–4th arr., 2002.

260 / **JOSÉ MARIA GONZALEZ**, *Accumulation of Things*, posters, Bastille, 4th–12th arr., 2002.

261 / **ANONYMOUS**, *Houses Pasted on a Squat*, photocopied posters, rue de Poitou, 3rd arr., 1999.

262 / **LA MIRE (TEST CARD)**, *Test Card Project*, poster, 5th arr., 2006.

- - - -

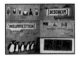

263 / **KINKIN**, *Monster Crew*, silk-screen cutouts pasted on wall, passage des Taillandiers, 11th arr., 2005.

264 / **FRANÇOIS MOREL**, *Insurrection*, collage, rue Giffard, 13th arr., 2005.

265 / **ANONYMOUS**, *Penguins*, posters pasted on wall, rue Denoyez, 20th arr., 2005.

266 / **FRANÇOIS MOREL**, *Disobey*, poster, rue de Bagnolet, 20th arr., 2005.

267 / **JR**, *Street Show*, posters and spray painting, rue de Charonne, 11th arr., 2002.

268 / **LES MIAM'S (THE YUMS)**, *Series of 3 Miams*, marker on sticker, place Sans-Nom, rue Oberkampf, 11th arr., 2002.

- - - -

269 / **JEROME MESNAGER**, *The White Man and the Rainbow*, paint and stencil, 20th arr., 1996.

270 / **NEMO**, *Negative Images of the Head of the Black Man*, stencil, Mouffetard, 5th arr., 2004.

271 / **MOSKO ET ASSOCIES (MOSKO AND ASSOCIATES)**, *Giraffe*, stencil, 19th arr., 1996.

272 / **ZAO**, *The Monkey*, stencil, rue de la Grange, 5th arr., 1996.

273 / **MOSKO ET ASSOCIES**, *The Savannah*, stencil, 19th arr., 1996.

274 / **MOSKO ET ASSOCIES**, *Zebras and Pink Flamingos*, stencil, 19th arr., 1996.

275 / **MOSKO ET ASSOCIES**, *Giraffe Profile*, stencil, 19th arr., 1996.

276 / **SPEEDY GRAPHITO** and **MOSKO ET ASSOCIES**, *Tiger in the Rue des Rosiers*, paint and stencil, rue des Rosiers, 4th arr., 2005.

- - - -

277 / **JEROME MESNAGER**, *The White Man Goes Up the Stairs*, paint and stencil, Belleville, 19th–20th arr., 1997.

278 / **ELFEMAR**, *The Staircase*, stencil, rue du Perche, 3rd arr., 1997.

279 / **ANONYMOUS**, *Footprint*, stencil, Ménilmontant, 20th arr., 2001.

280 / **NEMO** and **JEROME MESNAGER**, *Puzzle*, stencil and paint, canal de l'Ourcq, 19th arr., 1996.

281 / **JEROME MESNAGER**, *White Man with Clouds*, paint and stencil, 20th arr., 1996.

- - - -translation continued from page 120- - - -

113 / **VLP**: I Am a Piece of Utopia

120 / **MISS.TIC**: I made you walk [I fooled you]
I made you run
I'll make you fall

126 / **ANONYMOUS**: Knowledge is a weapon my friend!
I swear!

147 / **ANONYMOUS**: Atlantic
6'10
7'29" North
4'5" West

203 / **ELGER**: In one hundred years you'll all
be dead
Fly away

204 / **ANONYMOUS**: Every day, I wash my brain
with television.
[on brain] On sale

208 / **ANONYMOUS**: Your place is taken

212 / **NELUNDETH**: They're here
I saw them

264 / **FRANÇOIS MOREL**: Insurrection
[Sign] Office entrance

267 / **JR**: My own show is the street.

Bibliography

Monographies:

AEROSOL, JEF. *VIP: Very Important Pochoirs*. Paris: Alternatives, 2007.

DE FEO, MICHAEL. *Alphabet City: Out on the Streets*. Corte Madera, CA: Gingko Press, 2004.

FAUCHEUR, JEAN. *Jusque-là tout va bien!*. Paris: Critères éditions, 2004.

JACE. *Défense d'afficher*. Paris: self publication, 1999.

___. *Les Spasmes urbains*. Paris: self publication, 2001.

___. *Le Petit Livre rouge*. Paris: self publication, 2003.

JR. *Carnet de rue*. Lyon: Free Presse, 2005.

JR AND LADJ LY. *28 millimètres: portrait d'une génération*. Paris: Alternatives, 2006.

JR AND MARCI. *Face 2 Face*. Paris: Alternatives, 2007.

KAMI. *Exhibition catalogue*. Paris: La Base 01, 2003.

L'ATLAS. *L'Art du sens*. Paris: Critères éditions, 2004.

MESNAGER, JÉRÔME. *20 ans qu'il court*. Paris: Critères éditions, 2004.

MISS.TIC. *Je ne fais que passer*. Paris: Éditions Florent Massot, 1998.

___. *Miss.Tic in Paris*. Paris: Critères éditions/Paris musées, 2005.

MOSKO AND ASSOCIATES. *Peignez la girafe*. Paris: Critères éditions, 2004.

OBEY GIANT. *Exhibition catalogue*. Paris: La Base 01, 2003.

PAELLA CHIMICOS. *1985–1999, Monologue à bâtons rompus*. Paris: self publication, 1998.

PENNAC, DANIEL. *Nemo*. Paris: Hoëbeke, 2006.

SPACE INVADER. *L'Invasion de Paris*. Paris: Éditions Frank Slama, 2003.

SPEEDY GRAPHITO AND DANIEL CRESSON. *L'Aventure intérieure*. Paris: Critères éditions, 2004.

Books:

BAILLY, JEAN-CHRISTOPHE. *Sérigraffitis*. Photographs by Joerg Huber. Paris: Hazan, 1986.

BURNS, KELLY. *I NY: New York Street Art*. Berlin: Die Gestalten Verlag, 2005.

DROUIN, MICHEL. *Paris murmure: 20 ans de graphisme populaire*. Paris: Éditions Dittmar, 2006.

GIVERNE, ANTONIN. *Hors du temps*. Benicarlo, Spain: ColorsZoo, 2005.

GRODY, STEVE. *Graffiti L.A.: Street Styles and Art*. New York: Harry N. Abrams, 2006.

HUNDERTMARK, CHRISTIAN. *The Art of Rebellion: The World of Street Art*. Corte Madera, CA: Gingko Press, 2005.

___. *The Art of Rebellion 2: World of Urban Art Activism*. Mainaschaff, Germany: Publikat, 2006.

KANARDO. *Art de rue: Worldwide Street Stuff*. Lyon, France: Free Presse, collection Minibook, 2004.

LEMOINE, STÉPHANIE, AND JULIEN TERRAL. *In situ: un panorama de l'art urbain de 1975 à nos jours*. Paris: Alternatives, 2005.

LONGHI, SAMANTHA. *Stencil History X*. Paris: Éditions C215, 2007.

MACNAUGHTON, AXEL. *London Street Art*. Munich, Germany: Prestel, 2006.

MANCO, TRISTAN. *Stencil Graffiti*. London: Thames & Hudson, 2005.

___. *Street Logo*. London: Thames & Hudson, 2004.

MANGLER, CHRISTOPH. *Berlin City Language*. Munich, Germany: Prestel, 2006.

RIOUT, DENYS, DOMINIQUE GURDJIAN, AND JEAN-PIERRE LEROUX. *Le Livre du graffiti*. Paris: Alternatives, 1985.

STENCIL PROJECT. *Paris 2004*. Paris: Critères éditions, 2004.

TESSIER, YVAN. *Paris, art libre dans la ville*. Paris: Herscher, 1991.

WALDE, CLAUDIA. *Sticker City: l'art du graffiti papier*. Paris: Pyramyd éditions, 2007.

ZIMMERMANN, SVEN. *Berlin Street Art*. Munich, Germany: Prestel, 2005.

Collectives:

Graffiti Art. Photographs and layout by Éric de Ara Gamazo. La Tour d'Aigues, France: L'Aube, 1992.

Izastikup: A Unique Collection of Stickers. Edited by B0130, The Don, Microbo, Rome, and Drago Arts & Communication. 2005.

Souvenirs de Paris. Edited by Blek, Olivier Stak, André, Space Invader, Sam Bern, HNT, and ZEVS. Paris: self publication, 2001.

Stick'Em Up. Edited by Mike Dorian, Liz Farrelly, and David Recchia. London: Booth-Clibborn, 2002.

Street Art: Characters. Barcelona, Spain: Monsa, 2007.

Street Art: Stickers. Barcelona, Spain: Monsa, 2007.

Une nuit. Preface by Tom-Tom. Bagnolet, France: Kitchen 93, 2007.

Artists' web sites:

ABOVE
www.goabove.com

ALËXONE
www.alexone.net

ANDRÉ
www.monsieura.com

THE ART OF URBAN WARFARE
www.aouw.org

ASBESTOS
www.theartofasbestos.com

BENSMANA
Gilbak.spc.org/colosseum/luna/gil/gilcv.html

BERNHEIM
crust.free.fr

BLEK LE RAT
bleklerat.free.fr
blekmyvibe.free.fr

BONOM
www.flickr.com/groups/bonom/pool

C215
www.c215.com
www.flickr.com/c215

CHANOIR
chanoir.free.fr

DONVEZ, Miguel
www.migueldonvez.com

EAST ERIC
www.easteric.com

ELTONO
www.eltono.com
www.eltono.com/blog

EROSIE
www.erosie.net

FAFI
www.fafi.net

FAILE
www.faile.net

FAIREY, Shephard
www.obeygiant.com

FAUCHEUR, Jean
www.faucheur.fr
jean.faucheur.free.fr

FKDL (Frank Duval)
www.fkdl.com

FLOWER GUY
www.mdefeo.com

FLYING FORTRESS
www.flying-fortress.de

FLY-TOX
www.fotolog.com/flytox_one
www.myspace.com/flytoxone

FREMANTLE
www.thisisnotmywebsite.com

G (Jérôme Demuth)
human.ist.free.fr

GALLEGO, Antonio
1nous.free.fr

GAMARD, Antoine
www.gamard.com

GONZALEZ, José Maria
www.josemaria-gonzalez.com

GOUNY, David
davidgouny.free.fr

HAMON, John
www.paris-art.com
/interv_detail-2193.html

HAO
www.myspace.com/rockin_hao

HNT
honet.tk
hnteuropa.fr.st

INFLUENZA
members.chello.nl/j.jongeleen

IS BACH
www1.fotolog.com/isbach
www.myspace.com/janaundjs

JACE
www.gouzou.net

JEF AEROSOL
www.flickr.com/photos/jefaerosol
www.myspace.com/jefaerosol

JERK
www.9eme.net

JIEM
laluchasigue.free.fr

JR
www.jr-art.net
www.flickr.com/groups
/jrthephotograffeur/pool

KEFFER
www.konect.org

KINSEY, Dave
www.kinseyvisual.com

KOLEO
www.fotolog.com/koleo

L'ATLAS
www.latlas.net

LA MIRE
www.mire-project.com

LE PIGEON
hixsept.free.fr

LIFE REMOTE CONTROL
www.liferemotecontrolthemovie.com

LIGNESROUGES
www.eyeka.com/user/lignesrouges
www.fotolog.com/lignesrouges
/35293443

LUDWIGRAPHIK
www.flickr.com/photos
/ludwigraphik

MAMACITA
www.mamacita.buzznet.com/user

MESNAGER, Jérôme
mesnagerjerome.free.fr

MEZZO FORTE
mezzoforte.fr
www.myspace.com/mezzoforte3000

MISS.TIC
www.missticinparis.com

MONSIEUR CHAT
monsieurchat.eu

MOREL, François
fra.morel.free.fr
fra.morel.free.fr/fmv5

MOSKO ET ASSOCIÉS
moskoetassocies.fr

NEKOTWO
www.fotolog.com/nekotwo
/19394816

NEMO
www.lapanse.com/pages/graffitis
/carnets_de_nemo
/carnets_de_nemo.html

PAELLA
www.paellachimicos.com

PARAPLUIE
www.pebrock.blogspot.com

PEZ
www.lawebdelpez.com
fotolog.com/pezfotos

PINON, Patrick
www.patrickpinon.com

PIXAL PARASIT
www.splix.org
www.fotolog.com/pixal_parazit

PRUNE
www.prune-art.com

SADHU
www.myspace.com/sadhu1

SANG9
www.9eme.net

SPACE INVADER
www.space-invaders.com

SPEEDY GRAPHITO
speedygraphito.free.fr

STICKOPATHES
lesstickopathes.free.fr/site.html

36RECYCLAB
www.36recyclab.com
fotolog.com/36recyclab

TI.TIKI
www.fotolog.com/titiki
www.flickr.com/photos/ti-tiki/

VEENOM
fabien.ferry.free.fr/veenom

VLP
www.vlpblog.zeblog.com

YACOËL, Yves
shukaba.org/YvesYacoel.html

YZ/OPEN YOUR EYES
www.openyoureyesproject.com
open.your.eyes.free.fr

ZBS
www.myspace.com/zbsdesigners

ZEVS
www.patriciadorfmann.com/artist
/zevs/

- - - -

General web sites:

www.artdanslaville.com
www.associationlemur.com
www.colorszoo.com
www.ekosystem.org
www.flickr.com/groups/sticker
www.fotolog.com/street_art
www.fotolog.com/tristan_manco
www.lapanse.com
www.last-mag.com
www.parispochoirs.com
www.roswitha-guillemin.com
www.stencilrevolution.com
www.streetsy.com
www.unenuit.tk
www.visualresistance.org
www.woostercollective.com

- - - -

Translated from the French by Nicholas Elliott

Project Manager, English-language edition: Magali Veillon
Editor, English-language edition: Jon Cipriaso
Designer, English-language edition: Shawn Dahl
Cover Design, English-language edition: Neil Egan
Production Manager, English-language edition: Jules Thomson

Library of Congress Cataloging-in-Publication Data

Grévy, Fabienne.
 Graffiti Paris / photographs by Fabienne Grévy ; translated from the French by
 Nicholas Elliot.
 p. cm.
 ISBN 978-0-8109-7089-2
 1. Mural painting and decoration, French—France—Paris. 2. Graffiti—France—
 Paris. 3. Street art—France—Paris. I. Title.

 ND2746.G74 2008
 751.7'30944361—dc22
 2007052064

Works by AKIM, L'ATLAS, Gil BENSMANA, Simon BERNHEIM (SAM BERN),
Yseult DIGAN (PRUNE), Miguel DONVEZ, Franck DUVAL (FKDL), FAFI, Jean
FAUCHEUR, Antonio GALLEGO, Jérôme MESNAGER, MISS.TIC, MOSKO &
ASSOCIÉS, NEMO, PAELLA CHIMICOS, SPEEDY GRAPHITO, VLP, and ZEVS
copyright © 2008 ADAGP, Paris

Copyright © 2008 Éditions de La Martinière, an imprint of La Martinière
Groupe, Paris
English translation copyright © 2008 Abrams, New York

For information about special discounts for bulk purchases, please contact
Harry N. Abrams Special Sales at specialsales@hnabooks.com or phone
212-229-7109.

Printed and bound in Italy
10 9 8 7 6 5 4 3 2 1

harry n. abrams, inc.
a subsidiary of La Martinière Groupe

115 West 18th Street
New York, NY 10011
www.hnabooks.com